A BRIEF HISTORY OF
CHARLES
VILLAGE

A BRIEF HISTORY OF
CHARLES VILLAGE

Gregory J. Alexander & Paul K. Williams

Charleston London

THE
History
PRESS

Published by The History Press
Charleston, SC 29403
www.historypress.net

First published 2009

Manufactured in the United States

ISBN 978.1.59629.618.3

Library of Congress Cataloging-in-Publication Data
Alexander, Gregory J.
A brief history of Charles Village / Gregory J. Alexander and Paul K. Williams.
p. cm.
Includes bibliographical references.
ISBN 978-1-59629-618-3
1. Charles Village (Baltimore, Md.)--History. 2. Johns Hopkins University--History. 3.
Goucher College--History. I. Williams, Paul Kelsey. II. Title.
F189.B16C473 2009
975.2'6--dc22
2008055286

CONTENTS

Charles Village is known for its warm hospitality and its community of dog walkers and cat lovers, including the authors' nineteen-year-old cat, Minnie, seen here in the front doorway.

ACKNOWLEDGEMENTS

While the authors researched and wrote this book over the course of more than two years, several individuals and organizations were instrumental in the process. The authors wish to express their gratitude to all those who helped make this book possible, including friends and family for their support and encouragement and Hannah Cassilly, commissioning editor at The History Press. Some special thanks go to Catherine Rogers Arthur of Homewood House; Tara Olivero of Goucher College's Special Collections Library; Nancy Gilpin of Gilman School; Emily Rafferty of the Baltimore Museum of Art; Saints Philip & James Catholic Church; Charles Village neighbors who offered tidbits and information to be included in the book and for their passionate encouragement and desire to have Charles Village's fascinating history be documented; Enoch Pratt Free Library; Maryland Historical Society; and our loyal pets, our constant writing companions.

For the purposes of this book, photo credits used will be abbreviated in the following manner: Library of Congress Prints and Photographs Division (LOC); Baltimore Museum of Art Archives and Manuscripts Collections (BMA); Goucher College Library (GCL); Enoch Pratt Free Library (EPFL); Saints Philip & James Catholic Church (P&J); Maryland Historical Society (MHS); and Gilman School Archives (GS). Those photos without citations are part of the authors' private collection.

INTRODUCTION

Charles Village is one of Baltimore's most notable and historic neighborhoods, home to stately late Victorian homes, a thriving college town area and prominent cultural, religious, commercial and educational institutions. *A Brief History of Charles Village* will explore the neighborhood's transformation from its inception as a country retreat for downtown residents to a diverse and gentrified neighborhood today composed of longtime residents, recent transplants, apartment renters and university students.

Beginning in Chapter One, the neighborhood's early grand estates will be explored. The two substantial land grants that compose most of Charles Village—Huntingdon and Merryman's Lott—were the foundation for the neighborhood, which would later be home to such grand early estates as the Vineyard, Gilmor, Liliendale, Wyman, Ulman and the famed Homewood House, built about 1801 by Charles Carroll, son of one of the richest men in America. Homewood House remains the sole surviving home of the era.

Chapter Two will detail how what is called Charles Village today came to be as an amalgamation of several small neighborhoods, including Old Goucher, Abell and Peabody Heights. The Peabody Heights Company, formed shortly after the Civil War in an effort to capitalize on Baltimore's anticipated growth and build high-quality residences in the suburbs, will be a special emphasis, as its formation and the leadership exhibited by its founders were critical to the formation of Charles Village as a neighborhood. Chapter Two will also detail how, after the Civil War, more and more Baltimore residents yearned for a more suburban lifestyle, the

development of public transportation—early horsecars—made commuting into the city easier from Charles Village and how, later, trolleys brought downtown residents to the neighborhood to watch the Baltimore Orioles play at Union Park stadium. Highlights in this chapter also include 200 East Twenty-fifth Street at the northeast corner of Twenty-fifth Street and Calvert Street, one of the oldest surviving homes in Charles Village; "Little Georgetown Row" on St. Paul Street; the unique slate-shingled cottage built on the northwest corner of St. Paul Street and Twenty-ninth Street, one of the earliest structures remaining in the grid system of streets that marked the beginnings of Peabody Heights; a *Titanic* survivor; and the Reverend John F. Goucher House, built in 1892 and the foundation of Goucher College.

Charles Village's architecture will be a special focus in Chapter Three, as the neighborhood's long rows of colorful row houses with distinctive front porches built in the early 1900s would later provide a means for former apartment dwellers downtown to own their own houses, and today they serve as a unique and well-known architectural feature of the neighborhood. The building boom at the onset of the twentieth century brought to Charles Village some of Baltimore's—and the country's, for that matter—most notable architects, who brushed a colorful palette upon what was then a very rural canvas. Although development primarily began in the southern areas of Charles Village and moved northward, the construction pattern did not follow a strict north–south or east–west progression. Instead, developers bought entire blocks at a time for development in a somewhat haphazard way. This chapter will also pay homage to some of the famous early residents in Charles Village, including wealthy businessmen, politicians, professional baseball players, physicians and musicians.

Chapter Four will tackle the rapid construction of apartment buildings to meet the demand of a burgeoning population in Charles Village. Contrary to today's perception of what apartment buildings tend to be in urban areas—large, plain, rectangular towers with cookie-cutter basic apartments—those built in Charles Village in the 1920s and 1930s were designed by famous architects of the day and featured luxurious appointments and innovative designs that catered to the upper-middle-class residents who yearned to leave downtown's congested atmosphere for a more "country" setting.

Charles Village's famed educational institutions, including Johns Hopkins University and the former campus of Goucher College, will be covered in Chapter Five. Johns Hopkins University's move from downtown Baltimore

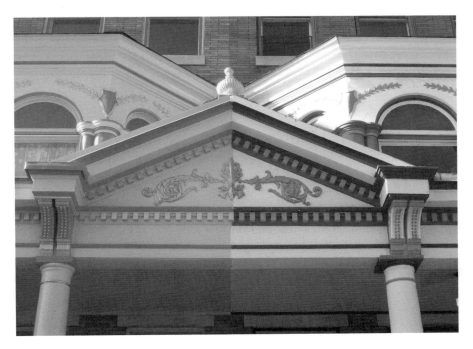

Many residents and visitors to Charles Village know the community for its colorful palette of Painted Ladies and striking color combinations between adjoining houses. Since most homes share a pediment, many homeowners consult with one another when painting.

to a leafy, country setting in Charles Village—thanks to a generous land donation by William Wyman—at the beginning of the twentieth century was vital to the neighborhood's growth and prestige factor. The school's worldwide reputation, its influence on the commercial, social and residential makeup of Charles Village and the inevitable "town and gown" effect will all be discussed. Additionally, Goucher College's influence, especially on lower Charles Village, will be included, as the school that once called Charles Village home had a profound effect on the neighborhood and continues to do so today.

The notable commercial, cultural, educational and religious institutions—creating a "city within a city"—will be the focus of Chapter Six. Charles Village has been home to beautifully designed churches over the years, and the neighborhood's diverse makeup has resulted in a multi-religious presence today. Religious institutions also played a key educational role, as several parochial schools used to reside in Charles Village. The Country School for Boys—later renamed the Gilman School—also contributed, as

the school's stellar reputation and convenience to downtown via streetcars introduced more prominent Baltimore families to Charles Village. The neighborhood's cultural institutions, most notably the Baltimore Museum of Art, and the various commercial developments—from early pharmacies to today's various restaurants and pubs catering to college students—will also be explored in this chapter.

Authors' Note: For the purpose of this book, the term "Charles Village," coined by Grace Darwin in 1967, will be used to refer to the various small neighborhoods within Charles Village.

GRAND ESTATES: FOUNDATION OF A NEIGHBORHOOD

The neighborhood known today as Charles Village can trace its roots to two of the earliest land grants in the emerging country. It is composed of both the original land tract called Huntington (later spelled Huntingdon) and one coined Merryman's Lott. Huntingdon comprised a 136-acre tract granted by Lord Baltimore in 1688 to Tobias Stanborough, an early settler of German descent. Lord Baltimore granted Charles Merryman the adjoining Merryman's Lott, which today would comprise parts of eastern Charles Village, along with the neighborhoods of Abell, Waverly, Oakenshawe and Guilford.

These two large parcels were later divided, beginning about 1790, into smaller yet sizable estates that were purchased by some of Baltimore's wealthiest citizens for use as summer homes and country retreats, often tended to by enslaved labor. The elegant homes would define the rural character of the area for the following century, despite the construction of "Little Georgetown Row" beginning in 1869 and the eventual formation of the Peabody Heights Company in 1870. A visitor to the area in the early 1800s wrote:

> *The suburban country of Baltimore is extremely beautiful, and no portion surpasses that lying to the north of the city. That section extending from Druid Hill Park to Clifton, the seat of Johns Hopkins University, and Lake Montebello, is one of the most picturesque in America. It is a panorama of uninterrupted beauty, diversified with almost every variety of scenery, to which man has contributed the works of art and industry.*

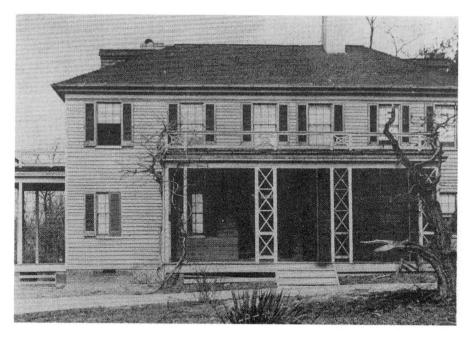

One of the earliest estates located in Charles Village was Roseland, which once stood at what would be today's intersection of Calvert and Thirty-first Streets and was located on the land that once was the Huntingdon estate. *EPFL*

Tobias Stanborough's 1688 land grant known as Huntingdon was seemingly in a constant state of flux, with parcels and pieces both added and subtracted to eventually form a 475-acre plat by 1757. It was then solely owned by John and Achsah R. Carnan, members of the Charles Ridgely family, who had begun acquiring land in the area in 1746. Subsequent owners Henry Dorsey Gough and Thomas Bond Onion would forever change the large tract, however, when they began selling and leasing smaller parcels to prominent Baltimore families for construction of large country estates. The village of Huntingdon was established in 1790 along the York Turnpike Road; renamed Waverly after the Civil War, it is where the early landowners of the Charles Village area would obtain supplies, attend church and hold social events.

The house and grounds known as the Huntingdon estate was built in the late eighteenth century where the intersection of Guilford Avenue and Thirty-second Street is today. Entered through Catbird Lane, the mansion served as the home of wealthy merchant James Wilson (1776–1851). He

erected a gambrel-roofed frame house later called the Cottage; it remained standing until 1915, when the Guilford Improvement Company demolished it to make room for modern dwellings. His relative, Dr. Franklin Wilson, was a Baptist minister and future investor in building lots that would become Charles Village. Following James Wilson's death in 1851, the land was divided among his children and became separate estates known as Roseland and Oakenshawe. Roseland was later owned by Robert Patterson.

One of the more well-known estates that developed on this land beginning in the 1790s was known as the Vineyard, situated on a knoll that is today the Barclay Elementary School playground. It was built by William Gilmor, whose father had made a fortune exporting tobacco following the Revolutionary War, and William's brother, Robert Gilmor Jr. (1774–1848), the renowned Baltimore art collector and founding member of the American Geological Society in 1819. William collected a large number of works on paper and oils during the 1830s and 1840s, and with his strong connections to the city's Peabody Institute, a major portion of his collection was donated to serve as the basis of the Peabody Art Collection. At a time when few of America's

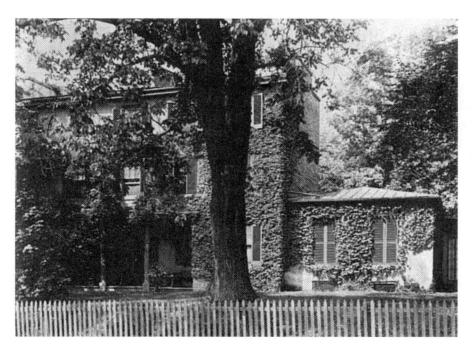

The genesis of the famed Vineyard estate dates back to Lord Baltimore's land grant in 1688. It was one of the largest estates in Charles Village and was located where the Barclay Elementary School playground is today. *EPFL*

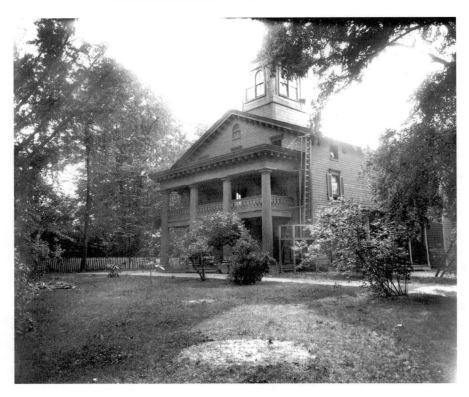

The Ross home was typical of the large country estates owned and enjoyed by Baltimore's wealthy residents during the summer months. This imposing mansion stood at what is today Thirtieth Street and Vineyard Lane. *MHS*

major art museums and private galleries contained anything more than family portraits, Gilmor purchased almost one thousand works, including drawings by eighteenth-century Italian draughtsmen, French artists and artists across Europe. He is credited with being one of artist Thomas Cole's first patrons, but he asserted that Cole should place human beings into his landscape paintings to counter the natural landscape with the character and spirit of human beings. He and Cole argued on this point, which became on ongoing debate among early American landscape painters and continues into the twenty-first century.

The Gilmor estate was accessed from Vineyard Lane, then a main country thoroughfare that ran from Twenty-seventh Street and St. Paul Street northeast to the York Road turnpike tollhouse. The Vineyard was later home to the prominent Whitely family. Another estate, known as Liliendale,

belonged to merchant Hugh Thompson, a bachelor and business partner of Robert Oliver, a prominent exporter and importer of the day.

Just north of the Vineyard, set between today's Guilford and Barclay Avenues, Twenty-ninth and Thirty-first Streets, was an imposing residence built by the Ross family, accessible from Vineyard Lane.

Other early estates in the area were owned by the Sumwalt family, proprietors of a stone quarry that provided much of the building material for early downtown municipal buildings. The Sumwalt Creek, which stretched from today's University Parkway to the Wyman Park Dell mostly down what would become St. Paul Street, was thus named. Another estate was home to the Sadtler family. Sadtler history in Baltimore began when the family patriarch, Philip Benjamin Sadtler, emigrated from Germany in 1799 at age twenty-eight, establishing what would become a successful silversmith and optical shop in the city. Sadtler silver marks, representing several descendants of silver making, are highly collectible today.

Named after the original land grant, the Huntington Baptist Church on the northwest corner of Thirty-first Street and Abell Avenue was founded in 1829 as a small Sabbath school for convalescent soldiers stationed in camps established near Old and New York Roads to escape the malaria-prone areas found around Fort McHenry.

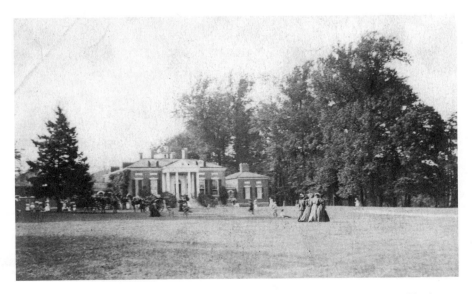

Charles Carroll, one of the richest men in America, deeded 155 acres to his son, Charles, who built the Federal-style Homewood House around 1801. It remains the sole surviving home of the era. *GS*

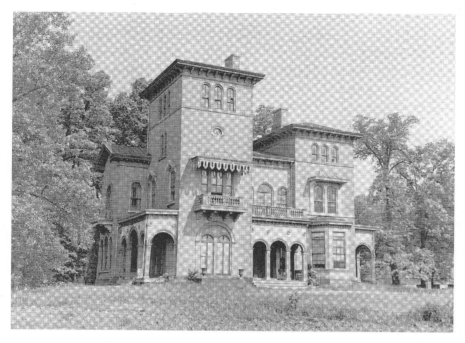

Built in 1853 near the site of today's Baltimore Museum of Art on North Charles Street, the large Wyman estate formed the basis for the campus of Johns Hopkins University. *EPFL*

A large portion of the westernmost part of the 1688 Huntingdon land grant came into the hands of wealthy Charles Carroll of Carollton. One of the richest men in America at the time, he deeded 155 acres to his son Charles upon his 1800 marriage to Harriett Chew of Philadelphia. The tract became known as Homewood, and Charles built the magnificent Federal-style Homewood House on its highest peak beginning about 1801. Much has been written and documented about Homewood House, which Charles Carroll III sold in 1839 to Samuel G. Wyman, who would add his own estate house and stone gatehouse to its southern grounds in 1853. Wyman's two children, William and Elizabeth Aldrich, would eventually sell the divided parcels in 1901, after much negotiations, to Johns Hopkins University. Today, Homewood House is a museum operated by Johns Hopkins University and features period furniture and colonial interpretation.

Samuel Brady (1789–1871), the mayor of Baltimore from 1840 to 1842, lived in a modest log and wood frame house situated at Thirtieth Street and Vineyard Lane. Brady was born in Delaware and first entered politics

when he ran for the Maryland State House of Delegates in 1834. Following his service as mayor, he ran unsuccessfully for a seat in Congress as a U.S. representative from Maryland in 1842. He remained at the house until his death on December 8, 1871.

Prosperous wholesale dry goods merchant Samuel G. Wyman, who had purchased the Homewood House estate in 1839, decided he wanted a new house built on the vast grounds after viewing designs by well-known architect Richard Upjohn that appeared in the popular book of the day *Architecture of Country Houses*, by Andrew Jackson Downing.

Wyman had approached Upjohn in 1851 in New York, but the men never agreed upon terms, and Wyman returned to Baltimore to find a local builder to replicate the design from the book. Completed in 1853, the Italianate-style villa closely replicated the Upjohn original because Wyman had hired a Newport, Rhode Island carpenter who had worked on the original design, built for Edward King. His son, William Wyman, lived in the house until 1903.

Concerned that his estate would be bought by local developers and divided up, Wyman had earlier, in 1898, donated his sixty-acre estate to the financially strapped Johns Hopkins University for relocation of its campus and an area known as the Dell for use as a park. Johns Hopkins University razed the villa in 1954, but its elaborate gatehouse exists today, located at the corner of North Charles Street and Art Museum Drive, serving as the school's newsletter office.

When the Wyman villa was built, little transportation existed in the area, with the exception of Sumwalt Lane, a road that then led to the settlement known as Oxford, today's Harwood neighborhood near Twenty-fifth Street and Abell Avenue. However, in 1854, Charles Street was extended north from Twenty-third Street for more than four miles as a toll road, extending to today's Bellona Avenue. That same year, Huntington Avenue was laid out running east and west, known today as Twenty-fifth Street.

In the early 1860s, a large portion of the tract was purchased for the Agricultural and Mechanical Association, where many state fairs were held. Upon the onset of the Civil War, it was converted into an encampment known as Camp Bradford. The Federal government first used the area to recruit and train thousands of Union soldiers and subsequently to operate a one-thousand-patient military hospital under the direction of Dr. J.T. Brown. The site was described in 1864 as "high and healthy, and possesses many attractions from the beauty of the position and its proximity to some of the finest and most elegant residences and farms in Baltimore County. A field of several acres is in front of the barracks, is used as a drill ground, and

The only vestige left of the Wyman estate is its elaborate stone gatehouse, located at the end of the forested drive. A then rural North Charles Street is shown here in the foreground. *GS*

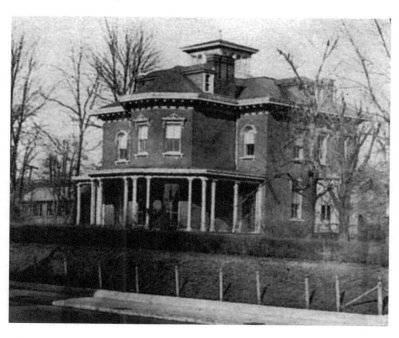

Liquor merchant Alfred Ulman built this impressive estate in the 1870s at Twenty-eighth and North Charles Streets. It was razed in 1927 by Saints Philip & James Catholic Church to make way for a new church. *EPFL*

there is quite a handsome grove in the rear. Its name is ordered in honor of Governor Bradford, whose residence is within two miles of the camp."

Following the Civil War, city planners realized the value of the land adjoining the northern sections of the city and began to plan an imposed grid system of streets over private parcels, setting the stage for modern-day Charles Village. The Baltimore, Peabody Heights and Waverly horsecar line was established in 1872. Although early transportation was slow and erratic, by the mid-1800s, horsecars ran along St. Paul Street and Maryland Avenue, allowing easy, safe and convenient transport to the city center. This set the stage for the demise of the rural setting and the rapid development that would follow. It was described at the time as follows: "Graceful villas crown its heights, luxuriant gardens repose on its valleys and hill sides, lakes and streams sparkle amid its emerald fields. In the midst of this scene and on one of its crowning heights, the property of the Peabody Heights Company is situated."

Some of the early estates built in the area remained long after they had become surrounded by the row houses built in the twentieth century. One of these was the large Ulman estate, with its large mansion built sometime between 1871 and 1879 by wealthy liquor merchant Alfred J. Ulman. Although it composed a much larger property, when the grid pattern of streets was laid out in Charles Village, the house became known as 2801 North Charles Street. It remained until 1927 on the site between where the Saints Philip & James Church and rectory buildings are now located; the block is bordered by Twenty-eighth and Twenty-ninth Streets, North Charles Street and Lovegrove Alley.

A.J. Ulman, as he was known, was born in Germany in 1830 and emigrated twenty years later aboard the SS *Esperanza*. He and sixteen other individuals were recorded as occupying the house and its many outbuildings in the 1880 census. In addition to his wife Clementine and their four children, the family also had a live-in cook, maid, gardener, nurse, coachman, several servants and even a resident florist.

Cardinal Gibbons and Father Wade of the Saints Philip & James Church bought the Ulman mansion from a subsequent owner on March 20, 1920, for an astonishing $111,680.75. They rented the house for a while to the University School for Boys, also known as Marston's Academy. The house was razed in 1927 to make way for the construction of the present-day .church and rectory.

Other early estates built by 1878 included those owned by builder William Allen, banker Albert Williams, dry goods merchant Henry Stouffer,

oil man Roland Rhett, miller Charles Dickey, builder Augustus Clemons, china manufacturer Edwin Bennett and William and Anna P. Holmes. The extended Holmes family, typical for the area, included twelve individuals, all attended to by a live-in black waiter, a cook, two servants and a coachman. Liquor merchant George W. Sattler and his family lived in a large brick house built in the block bordered by today's St. Paul, Charles, Twenty-fifth and Twenty-sixth Streets, where they were enumerated in the 1880 census. They also had two live-in black servants and a cook.

Carpenter William Sadtler and his large family, also recorded in the 1880 census, resided in the area. He was born in Maryland about 1818, and he and his wife Margaret, born in Maryland about 1822, lived there with their nine children, several of whom were carpenters and painters. The family also had a live-in black servant named Fannie Gray, who was born in North Carolina about 1851, and a live-in black cook named Nancy Norris, who was born in Virginia about 1849—both were likely born enslaved.

The vast majority of these early estates representing gentrified country living no longer exist, with only a few remaining wandering lanes to remind residents today of their locations. The Homewood House on the Johns Hopkins campus remains today as nearly the only remnant of the numerous and prosperous early estates that once were home to early land grant recipients and Baltimore's wealthy and prominent families.

POST–CIVIL WAR MIGRATION TO THE SUBURBS

As the nineteenth century was winding to a close, a few estates remained in Charles Village, while others were razed to make way for the burgeoning row house development that was about to take place. Originally called Peabody Heights in an attempt to capitalize on the prestige of the name George Peabody, a well-respected, upscale citizen who was the benefactor of the famed Peabody Institute, the genesis of what would later become one of Baltimore's earliest planned suburban developments was the foresight of the Peabody Heights Company.

The neighborhood's grid system was the ideal template for developers to focus in on a particular block and target it for a series of similar homes to be built simultaneously. (One of the few exceptions to the grid system in Charles Village is Vineyard Lane, which has a diagonal orientation, a testament to the former estate, the Vineyard, that once stood there.) Another attractive element that Charles Village had going for it was that the higher elevation afforded potential homeowners a country setting while still being conveniently located close to downtown via first horse-drawn carriages and later the streetcar system and to some residents' summer residences in Roland Park. The higher elevation also lent itself to attractive views of Baltimore City. Also beneficial to the success of the developers of Charles Village was the ability to boast that residences would be situated in proximity to the well-known estates, including the Ulman, Vineyard and Wyman estates.

Shortly after the Civil War, in an effort to capitalize on Baltimore's anticipated growth, the Peabody Heights Company was formed on October 1, 1870, in

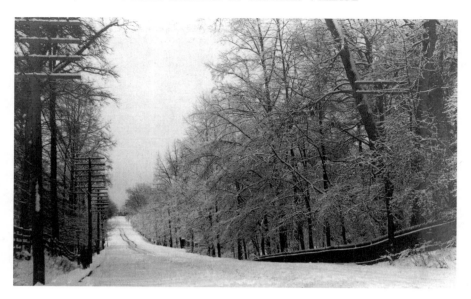

This 1906 photo of North Charles Street in the snow looking south from Thirty-first Street depicts the extremely rural nature of Charles Village at the time, as residential development had yet to occur. *GS*

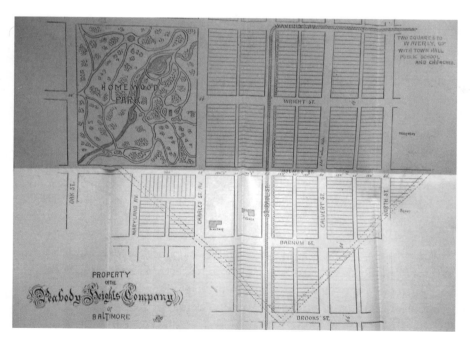

The Peabody Heights Company was established in 1870 with grand plans for a suburban planned community, although development would not happen for twenty years, due in part to the 1873 and 1893 depressions in America.

order to build high-quality residences in the suburbs. The founding members included two real estate brokers, a Baptist minister and a brick manufacturer. The reason for its formation was the purchase of the fifty remaining acres of the Liliendale estate, bounded by what are today Twenty-seventh and Thirty-first Streets and Maryland and Guilford Avenues. The company's president was Dr. Franklin Wilson, an evangelical minister and relative of James Wilson, owner of the Huntingdon estate. His witnessing several congregations moving to the suburban areas and paying dearly for land in previously developed communities likely formed the basis for this new company to be proactive rather than reactive in its development plans.

With its large parcel, the company planned a grid pattern of streets with approximately twenty large blocks divided into individual building lots twenty-five feet wide. No streets were graded, as the plan appeared on paper only, but the deed records were established with a string of building restrictions and covenants to ensure a first-class architectural aesthetic and well-planned community, one of the first such attempts at controlled zoning. Houses were to be set back twenty feet from the street, along with the prohibition of nuisances such as "slaughter houses, offensive manufacturing establishments, lager beer saloons or places for the sale of intoxicating drinks, or building calculated to increase the rates of insurance on adjacent property."

Company brochures were produced that described the area as "a panorama of uninterrupted beauty, diversified with almost every variety of scenery, to which man has contributed the works of art and industry. Graceful villas crown its heights, luxuriant gardens repose on its valleys and hill sides, lakes and streams sparkle amid its emerald fields. In the midst of this scene and on one of its crowning heights, the property of the Peabody Heights Company is situated." The company claimed that a view from this location included Druid Hill Park, the city skyline, Chesapeake Bay and even Kent Island.

Fate and factors beyond the company's control, however, would shorten the vision planned by its directors. As if the restrictions were not enough, the country entered into an economic depression in 1873, and another one in 1893. The deed restrictions were meant to increase the building lot prices so that homes of a commensurate measure would be built, but with the economic outlook of the country stalled for more than two decades, little building took place on any of the Peabody Heights Company land until 1896. That year, the undeveloped tract was purchased by Francis Yewell, who in 1897 would sell the first of literally hundreds of row houses that he would build on the parcel on the west side of the 2700 block of St. Paul Street.

1865–1890: Early Beginnings

Although the majority of the residential development in Charles Village occurred in the late nineteenth and early twentieth centuries, the neighborhood's genesis actually began around the conclusion of the Civil War. One of the oldest houses in the Charles Village area that survives from that era is found at the northeast corner of Twenty-fifth Street and North Calvert Street, a building that has been severely altered over the years. The home was built along what was then a rural road about 1865 and was the home to Confederate veterans Dr. James McHenry Howard (1839–1916), Harry Carroll Howard (1842–1921), David Ridgley Howard (1849–1927) and William Ross Howard (b. 1837), all grandsons of John Eager Howard (1752–1827), the fifth governor of Maryland and namesake of Howard County, Maryland.

About four years later, six homes unique in design were built in the 2600 block of St. Paul Street. Commonly known as "Little Georgetown Row," the set-back houses between 2610 and 2620 St. Paul Street were built by separate owners over a period of about ten years, beginning in 1869. The narrow yet deep homes are unusual in Charles Village in that they are set back from the road and some of them, including 2622 St. Paul Street, feature upper and lower side porches. The striking homes have many decorative touches, such as a rare cast-iron fence at 2620 St. Paul Street.

Little Georgetown Row on St. Paul Street also has been the home to some notable individuals in Charles Village. For example, the house at 2616 St. Paul Street was once the home of sculptor Simone Brangler Boas (1895–1981),

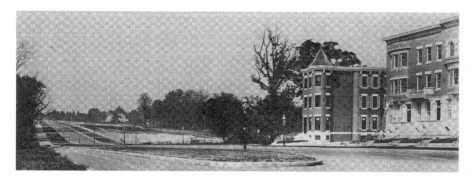

This August 1909 photo of the Olmsted-designed North Charles Street looking north illustrates how residential development was halted at Twenty-ninth Street. The Olmsteds also designed Wyman Park, adjacent to North Charles Street. *EPFL*

who lived here with her husband, Dr. George J. Boas (1891–1980), and had a studio in the carriage house behind the home—2617 Lovegrove Street—that she shared with fellow sculptor Elsa Hutzler (b. 1906), a relative of Moses Hutzler, who came to Baltimore from Bavaria in 1836 and whose three sons in 1858 established the Hutzler's department store. The French Mansard–style home with striking deep red windowpanes is now the home to journalist and author Jacques Kelly, a longtime columnist for the *Baltimore Sun*.

Other prominent residents in Little Georgetown Row through the years have included radio and television personality Cal Schumann (2612 St. Paul Street), as well as Soviet spy Whitaker Chambers (2610 St. Paul Street), who defected and testified against Communist spy Alger Hiss, wrote the bestseller *Witness* and was posthumously awarded the Presidential Medal of

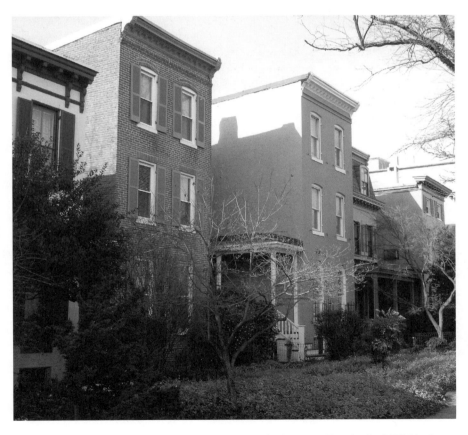

One of the first developments in the area was Little Georgetown Row in the 2600 block of St. Paul Street, built in the late 1860s. The homes have long been occupied by famous artists, journalists and even Soviet spies.

A descendant of President James K. Polk, W. Stewart Polk was one of the first prominent residents of Charles Village. His house still remains today. *From* Baltimore: Its History and Its People, *1912*.

The imposing Polk mansion at 2900 St. Paul Street is still a prominent fixture today in Charles Village, as seen here in 1903, when the area was still quite rural. *EPFL*

Freedom in 1984 by President Ronald Reagan, who credited Chambers's book as the inspiration behind his conversion from a New Deal Democrat to a conservative Republican. Another notable writer lived at 2610 St. Paul Street at one time—novelist and journalist R.P. Harriss. According to his obituary in the September 29, 1989 edition of the *New York Times*, Harriss was considered the "dean of Baltimore's working journalists." He penned his last column for the *Baltimore Sun* just two days before his death from cancer at the age of eighty-seven. According to his obituary, Harriss was "one of the last of a group of breezy, irreverent editorial writers and columnists in Baltimore who reached their peak in the 1920s and 1930s. The group included H.L. Mencken, who dedicated a book to Harriss."

One block north of Little Georgetown Row on St. Paul Street lie the two houses that in all likelihood represent the first two properties built on land owned by the Peabody Heights Company—2716 and 2718 St. Paul Street. The two brick-front homes were constructed between 1870 and 1871.

Meanwhile, the slate-shingled cottage built on the northwest corner of St. Paul and Twenty-ninth Streets is one of the earliest structures remaining in the grid system of streets that marked the beginnings of Peabody Heights. It was built in 1879 for William Stewart Polk, a descendant of both President James K. Polk and artist Charles Willson Peale.

W. Stewart Polk, as he was known, was an insurance agent and broker with offices in the Baltimore Fire Insurance Building and a second office located at St. Paul and Tenth Streets, where he was an agent for the Liverpool, London and Globe Insurance Companies. His occupation and expertise in fire insurance likely led to the unusual slate shingles being installed as siding on the house when they were usually reserved for roofing material. Polk, who was born in March 1842 in Maryland, married Kentucky native Louisa Ellen Anderson in 1869. The 1900 census was recorded at 2900 St. Paul Street in June of that year and showed that they shared the house with their sons Anderson, born in 1870, and David Peale, born in 1879, who worked as an insurance salesman for his father. The family also had a live-in white servant named Mary Crimson who was a native of Pennsylvania. W. Stewart Polk died in 1917.

TITANIC SURVIVOR

Another daughter of the Polks who grew up at 2900 St. Paul Street was named Lucile, born on October 8, 1875, and a belle of the city at the time

of her debut. She boarded the ill-fated *Titanic* at Southampton on April 10, 1912, along with her husband William Ernest Carter and their children, Lucile, age fourteen, and William, age eleven. They were returning to America after several months in the Melton Mowbray district, the great southern English hunting grounds, where Ernest was a familiar figure in the international polo set.

Mr. Carter was born on June 19, 1875, and his family maintained homes in Bryn Mawr, outside Philadelphia, and Newport, Rhode Island. He was descended from one of the oldest families in the Quaker City, his grandfather, William T. Carter, being one of the famous "old guard" anthracite coal operators.

The Carter family and their entourage occupied first-class cabins numbered B-96 and B-98. Also traveling was Mrs. Carter's French-born maid Auguste Serreplan, Mr. Carter's manservant Alexander Cairns and, in second class, Mr. Carter's chauffeur, Charles Aldworth. They were all listed on a ticket numbered 113760 that cost the Carters £120 for the one-way passage.

Lying in the forward hold of the *Titanic*, and listed on the cargo manifest, was the Carters' twenty-five-horsepower Renault automobile. The family also brought with them two dogs. William Carter would later claim $5,000 for the car and $100 and $200 for the dogs. On the fateful night of April 14, 1912, the Carters joined an exclusive dinner party held in honor of Captain Smith in the à la carte restaurant. The host was George Widener, and the party was attended by many notable first-class passengers. Later, after the ladies had retired and Captain Smith had departed for the bridge, the men chatted and played cards in the smoking room. After the collision with an iceberg, the Carters joined some of the other prominent first-class passengers as they waited for the boats to be prepared for lowering. Lucile and her children assembled alongside lifeboat four, with William just managing to join his mother and sister. After reluctantly allowing thirteen-year-old John Ryerson into the boat, Chief Second Steward George Dodd had demanded "no more boys," but Mrs. Carter put her large hat on young William's head and together they boarded the boat. Her maid Auguste Serreplan was also aboard.

Young William Carter refused to discuss the disaster in later years because he could never forget the memory of having to leave behind his old Airedale on a leash. Young Carter cried but was reassured by Colonel John Jacob Astor that he would take care of the dog, and the last young Carter saw of his beloved dog was Astor holding the dog's leash. It may have been this fact that led to the rumor that Astor retreated to the ship's kennels to release the dogs that were there.

Lucile Carter, daughter of W. Stewart Polk, was one of the many unfortunate passengers on the fateful maiden voyage of the *Titanic* in 1912. Luckily, she and her family survived.

After William Carter had seen his family safely into lifeboat four, he joined Harry Widener and advised him to try for a boat before they were all gone. But Widener replied that he would rather take a chance and stick with the ship. He might well have taken Carter's advice, for he lost his life while Carter was eventually able to escape. At about 2:00 a.m., Carter was standing near the officers' quarters. Collapsible lifeboats A and B remained lashed to the roof, but boats C and D had been freed and were being loaded. At one point a group of men desperately tried to rush boat C. Purser Herbert McElroy fired his pistol and the culprits were removed. The loading of women and children progressed, but eventually no more could be found, and as the boat was released for lowering, Carter and another man stepped in. The other passenger was Joseph Bruce Ismay, general manager of the White Star Steamship Company. The Carters' manservant Alexander Cairns and chauffeur Charles Aldworth both perished in the sinking.

Carter arrived at the *Carpathia* ahead of his family and waited on the deck, straining to see lifeboat four, which held his wife and two children. When it finally arrived, William did not recognize his son under a big lady's hat and called out for him; according to some sources, John Jacob Astor had placed the hat on the boy and explained that he was now a girl and should be allowed into the boat, but other sources suggest the more likely scenario of his mother's action in response to Chief Second

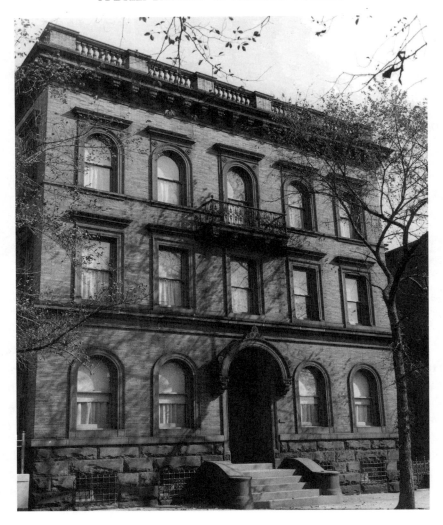

Built in 1892 and designed by the noted New York architectural firm of McKim, Mead and White, the Goucher House at 2313 St. Paul Street was home to Reverend John F. Goucher, founder of Goucher College. *GCL*

Steward George Dodd's order that no more boys were to enter lifeboat four. Reunited, the Carters disembarked in New York City aboard the *Carpathia* on Thursday, April 18, 1912.

They boarded a specially called ship bound for Philadelphia the following day. A reporter from the *Washington Times* spoke about the disaster with William Carter, who stated, "Terrible, terrible," pressing his hand in

weariness against his forehead. "No pen can ever depict and no tongue can ever describe adequately the terrors of our experience. Everywhere was a cold, hopeless despair and grief in its most hellish forms. Some were dumb with horror; others beat their breasts like things crazed; and a few laughed hysterically and insanely."

The disaster likely caused the demise of the Carters' marriage, and they divorced in May 1914. On August 16 of that year, Lucile Polk shocked society by returning from London, England, as the wife of wealthy Philadelphian George Brooke. She died in Philadelphia on October 26, 1934. Mr. Carter died in Florida on March 20, 1940.

REVEREND JOHN F. GOUCHER HOUSE, 1892

Reverend John F. Goucher was very familiar with the influential New York architectural firm of McKim, Mead and White when he decided to have it design his own residence at 2313 St. Paul Street in 1892. The firm had earlier designed his church under his direction—the First Methodist Episcopal Church (Lovely Lane), located close by at St. Paul and Twenty-second Streets, built between 1884 and 1887. It was just south of the Women's College of Baltimore, founded by Goucher in 1885 and later named after him.

Goucher built his own house in 1892 across from the school's campus. Instead of the more popular gray stone used at the time, architect Stanford White designed the house in a Renaissance Palazzo style, using yellow Pompeian brick with a stone balustrade. Goucher and his family would live at the house until 1922, when it was donated to Goucher College.

(The Peabody Heights Company system of grid streets was first laid out just north of Twenty-fifth Street, along either side of St. Paul Street. Today's numbered streets then had individual names, however; Twenty-seventh Street was Brooks, Twenty-eighth was Barnum, Twenty-ninth was Holmes, Thirtieth was Wright and Thirty-first was Waverly. Today's Howard Street was then known as Oak Street. In the 1890s, a large wood frame building known as St. Paul's Orphan Asylum was located where the Safeway store is today. It had earlier, in 1880, served as the Maryland Institution for the Instruction of the Blind, when sixty-eight students resided there.)

By the mid- to late 1800s, Charles Village was beginning to take shape; however, due to the neighborhood's northern location, it was still considered a very rural and remote country setting. At this time, Charles Village was still part of Baltimore County, a fact that would baffle many residents today,

This early view of St. Paul Street in 1901 shows the street abruptly ending at Thirty-first Street, with the newly constructed row houses contrasting with the rolling hills of what was then considered the suburbs. *P&J*

considering the neighborhood's sometimes hectic, fast-paced atmosphere and the ample buses, taxis and ambulances screaming down the main thoroughfares.

A key event that would spur interest in the "countryside" setting of Charles Village and help debunk the attitude that the area north of downtown was too remote for everyday living was the implementation of the streetcar system in Baltimore. First powered by horse or mule and later electricity and cables, the streetcars provided an easy and efficient way for suburban residents to access the conveniences of downtown Baltimore. There would be eventually approximately thirty-five different streetcar lines running in all directions in Baltimore by the early twentieth century; however, the first Frick line—named for George Frick, a Baltimore dry goods merchant who served as president of the Baltimore, Peabody Heights & Waverly lines from 1872 to 1885—was reportedly the Baltimore, Peabody Heights & Waverly

Post–Civil War Migration to the Suburbs

Railway of Baltimore County in late 1871. The Waverly line ran on Thirty-first Street, St. Paul Street, Charles Street and Maryland Avenue from Charles Village to downtown. In 1872, the Park Railway started laying tracks on North Avenue eastward to Charles Street to connect with the Peabody Heights & Waverly Railroad to Baltimore County, providing further access to downtown Baltimore for Charles Village residents. An 1891 streetcar map illustrates the efficiency of the streetcar system, as Charles Village residents could access all of downtown, Camden Station, West Baltimore, the burgeoning shopping of Howard Street and Johns Hopkins Hospital in East Baltimore.

With downtown within easy reach, more and more city dwellers began looking north to the idyllic setting of Charles Village and the opportunity to move from a small apartment downtown to a "country" home. Charles Village was at the cusp of a massive influx of residents, and developers began making plans to erect row houses by the hundreds to satisfy the need for ample housing. The late 1800s and early 1900s would be Charles Village's defining moment in residential construction.

A Neighborhood Takes Shape

By the late 1800s, several grand estates remained that dotted the landscape in Charles Village, as well as some pockets of development around the 2900 and 2600 blocks, including Little Georgetown Row on St. Paul Street. The establishment of the Peabody Heights Company in 1870 spurred some development on adjoining parcels, but it wouldn't be until the late 1890s that several large building developments would begin to define the future community. What was then considered Baltimore County and definitely the "country" for downtown dwellers, Charles Village was a new frontier to explore and offered a respite from the city heat. Long rows of affordable row houses with distinctive front porches built in the early 1900s provided a means for former apartment dwellers downtown to own their own homes. Today they serve as a unique and well-known architectural feature of the neighborhood.

1890–1899: Rapid Development

Little or nothing had been built on the land owned by the Peabody Heights Company since its organization in 1870, and by 1890, its Board of Directors and various investors were calling its earlier building restrictions an "absolute folly…but for these apparently harmless restrictions (the land) would have been sold years ago." They also regretted not building houses of their own to set an example of the quality of architecture and society planned for the future neighborhood. The various restrictions recorded on the individual

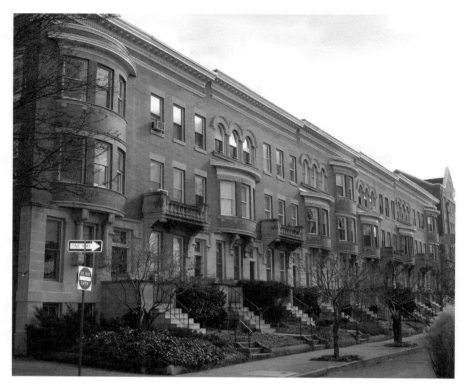

The row of houses built in the 2900 block of North Charles Street is unique in the neighborhood for the use of limestone on the ground floors and for the trim.

lots had stymied potential builders and land purchasers, even as the country emerged from a depression in the early 1880s.

Another factor that restricted widespread building in the area was the lack of bridges over the Jones Falls that limited access to the city. It wasn't until 1880 that substantial bridges were constructed over the Jones Falls at St. Paul and Calvert Streets and Guilford Avenue.

However, beginning in the 1890s, area residents would begin to witness unprecedented yet small development in Charles Village, with several independent entrepreneurs building on land outside the Peabody Heights Company land. About that time, the houses located between 30 and 56 Twenty-seventh Street were built. In 1890, a slew of houses were built in the neighborhood. The houses at 2620 Maryland Avenue, 104 and 106 East Twenty-fifth Street, 8 and 10 West Twenty-fifth Street and the three homes between 2500 and 2504 North Calvert Street were all built in 1890.

A Neighborhood Takes Shape

Starting with the first row house development, the building of 2501–2517 St. Paul Street, the mid- to late 1890s saw a residential boom in the once sleepy neighborhood, as more and more Baltimoreans looked north of the city for housing options.

A block away, the houses located at 2508–2520 North Charles Street were built by F. William Bolgiano, as well as 12–38 West Twenty-fifth Street and an individual house at 2618 Maryland Avenue. The following year saw a residential boom primarily centered on the 2500 blocks of North Charles Street, St. Paul Street and Maryland Avenue. Four homes were built between 2500 and 2506 North Charles Street, as well as the row houses located between 2501 and 2517 North Charles Street built by H.H. MacLellan, joining a short row built across the street a year earlier.

Not much is known about the purchasers of these early developments, as unfortunately, nearly the entire 1890 census for the country was destroyed in a January 1921 fire at the Commerce Building in Washington, D.C., where it was being stored. Its existence today would have been a critical record in detailing the occupants and owners of the earliest homes in Charles Village.

Also constructed in 1895 were the three structures at 2500 to 2504 St. Paul Street, which joined a row on the east side that had been built the year prior, and the homes located between 2501 and 2515 Maryland Avenue. They would be the only row houses located on the block for the next five years. An individual row house at 2613 Maryland Avenue and the homes located between 108 and 120 East Twenty-fifth Street were also constructed that year, as the neighborhood began to see development occurring in bunches.

Many of the early houses and buildings constructed in Charles Village were heated by Latrobe Stoves. These devices were invented in Baltimore by John Hazelhurst Latrobe (1803–1891), the son of noted engineer and architect Benjamin Henry Latrobe, and are sometimes coined Baltimore Heaters. They were squat and round, about twenty inches in diameter at the base, and stood about two feet high. They fitted into a fireplace opening and burned coal, requiring a daily cleaning of a somewhat messy ashtray. There were thirty-thousand in use by 1878 in Baltimore alone.

As residential development started to gain momentum, commercial development took off in 1896 in the 2500 block of St. Paul Street with the construction of both the Enoch Pratt Free Library and the original Margaret Brent School, followed in 1900 by the St. John's Methodist Church (see Chapter Six). As for residential development, the majority of the 2500 block of Howard Street, then known as Oak Street, was built. Those houses on the east side located from 2533 to 2553 were constructed by William F. Collett,

Self-taught architect Jacob F. Gerwig, seen here with his son, was responsible for the construction of the majority of homes during Charles Village's residential boom of the early twentieth century. *EPFL*

while those on the west side from 2500 to 2518 Howard Street were built beginning that year by John T. Reed.

Up until 1896, however, residential building in the area was somewhat slow paced and haphazard, until successful builder and realtor Francis E. Yewell, a native of Anne Arundel County, purchased the large section of land that once belonged to the Peabody Heights Company for an astounding $417,000. It took over a year for him to track down the original owners and descendants of the parcel, but when he settled on the land in April 1896, he began construction of thirty-six homes immediately. They included all but three houses on both sides of the 2700 block of St. Paul Street, and Yewell hired builder F.D. Sauerwein to construct the row located between 2701 and 2743 on the east side, as well as those across the street numbered between 2720 and 2746 St. Paul Street. Advertised in April 1897 between $4,000 and $7,000 each, with ample room for hundreds and hundreds more on his large parcel, other builders no doubt took note of Yewell's business savvy. The sales material noted that the homes were just a twelve-minute streetcar ride from Howard and Lexington Streets, were situated "on ground nearly as high as the top of the Washington Monument...and that all land in this neighborhood is held by owners who propose that such fine dwellings shall be erected as will make this Baltimore's finest location."

Yewell continued the prior strict covenants and building restrictions, and the homes on the block were made of glazed Roman brick and featured

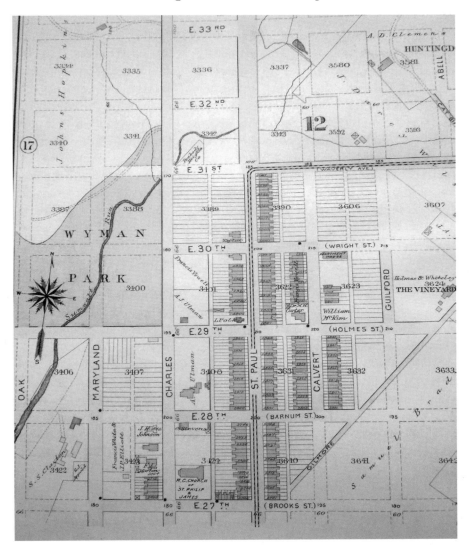

This 1906 atlas of Baltimore shows the beginnings of row house development and how some blocks looked at vacant land for many years, as many developers purchased entire blocks at a time.

striking façades with glorious accents. Inside, beautiful detailing, multiple bedrooms, tall ceilings and grand staircases awaited new residents, which would later include mayors, senators, Hall of Fame baseball players, prominent businessmen, doctors and lawyers.

It didn't take long for new residents to join together in an organization to better the emerging neighborhood. In 1899, in Peabody Hall, the neighborhood's central meeting place where residents could also purchase groceries, the Peabody Heights Improvement Association was formed to address some of the infrastructure and safety concerns of early residents. Membership in the Peabody Heights Improvement Association was limited to men but did include residents outside the original boundaries set by the Peabody Heights Company. Meetings primarily focused on "bricks and mortar" issues, such as the unpaved condition of St. Paul Street and the need for an increased schedule of the United Railways and Electric Company's streetcars. Other issues the association tackled included better lighting on city streets, increased police protection and the paving of neighborhood sidewalks. Within a few years, membership in the association grew from a few concerned residents to one-hundred-plus members. To help expedite resolution on its requests to city hall and to help form a closer relationship with city decision makers, the association held a banquet each year at the Belvedere Hotel, and the mayor and governor were invited. The association also promoted the neighborhood through annual picnics, an Independence Day fireworks display and welcoming events for new residents.

The Peabody Heights Improvement Association also fought city hall to have North Charles Street outfitted with carriage lanes and landscaped islands, a vision of the Boston-based architectural firm the Olmsted Brothers. The firm specifically targeted the Charles Street Boulevard, which began at Twenty-ninth Street and ran north to University Parkway. The Olmsted Brothers also designed Wyman Park, so it's natural that they wanted the portion of North Charles Street that abutted Wyman Park to mimic the designs found in Wyman Park. Hence, beautifully manicured landscaped islands were put in place on Charles Street Boulevard.

One of the Peabody Heights Improvement Association's lasting legacies is the erection of the large, iron fencing on Twenty-sixth Street that acts as a barrier to the Baltimore & Ohio Belt Line railroad tracks below. The tracks had been dug below grade beginning in 1890 parallel to Twenty-sixth Street to contain noise and eliminate the sight of trains. They were completed in 1893. Incidentally, the B&O retained a right to build a station between St. Paul and Charles Streets but never exercised its privilege.

Upon its completion in 1896, the house at 2701 St. Paul was sold to iron foundry owner James Bates, who resided there with his extended family and a black live-in servant. A widow named Francis Bates, a clerk in a coffee manufacturing business, rented 2713 St. Paul and lived there with

two of her grandsons and a cousin, along with two live-in servants. Two doors down, hotel owner Charles Callaghan lived with his wife Mary, five children and a servant at 2717 St. Paul, while Henry Yewell and his family resided at 2721 St. Paul. Factory owner Joshua Bates purchased 2741 St. Paul Street when it was completed in 1896 and lived there with his wife Emma and their four children.

Number 2728 St. Paul Street was home to Captain William C. Eliason, founder of the Tolchester Steamship Company, and later home to his son, Captain Henry C. Eliason. The Tolchester Steamboat Company was incorporated in 1878 to capitalize on the public interest in amusement parks located along the Chesapeake Bay. In 1887, Eliason established another company, the Tolchester Beach Improvement Company, to develop a resort at his newly acquired property at Tolchester Beach in Kent County. Located on the Sassafras River, the complex started with a hotel, restaurant, bathhouses, amusement park attractions and picnic grounds. It was heavily advertised in Baltimore, and it quickly became a popular destination for Baltimoreans. Tolchester Beach, in its prime, expanded to 155 acres and was serviced by six steamers and a twenty-two-foot-long ferry carrying twenty thousand visitors a weekend. The park eventually closed in 1962.

Captain William C. Eliason, founder of the Tolchester Steamship Company, lived at 2728 St. Paul Street. The company provided residents with an excursion on the Chesapeake Bay in the 1880s.

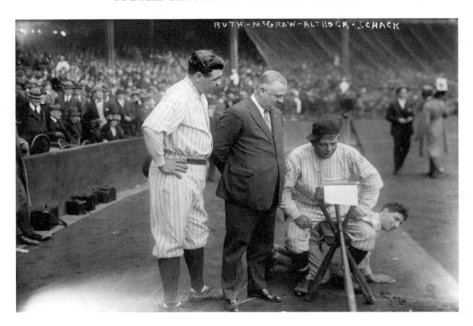

Charles Village resident John McGraw, seen here in the suit to the right of famed player Babe Ruth, managed the New York Giants after a successful stint as a player and manager for the Baltimore Orioles. *LOC*

Two neighboring houses at 2738 and 2740 St. Paul Street have ties to famous Baltimore Oriole players John McGraw and Wilbert Robinson. The house at 2738 St. Paul Street was purchased upon its completion in 1897 by John Joseph "Muggsy" McGraw, the Orioles' third baseman, New York Giants manager and baseball Hall of Famer.

The Baltimore Orioles' first incarnation began in 1882 as a charter member of the American Association, which was then a major league, when local brewer Harry Vanderhorst established a team with the primary object of selling beer at the stadium, located on Huntington Avenue. In 1889, the Orioles dropped out of the American Association but rejoined in 1890. In 1891, John McGraw, a fiery eighteen-year-old from Truxton, New York, joined the team. When the association folded, the Orioles joined the National League when the league decided to add four clubs to its membership. After a rough start in the National League, the Orioles caught fire and won three consecutive pennants from 1894 to 1896. After their first pennant win over Washington in 1894, a citywide parade went on for five miles. The Orioles followed up this effort with consecutive second-place finishes in 1897 and 1898.

A Neighborhood Takes Shape

Due to financial reasons, many of the team's stars were moved to Brooklyn in 1899, except for Charles Village residents John McGraw and Wilbert Robinson. McGraw and Robinson refused to leave Baltimore because they owned a successful establishment called the Diamond, a combination bar, billiards room and bowling alley. It has been said that the Diamond was the birthplace of duckpin bowling, a sport featuring miniature bowling balls and pins that is still popular in Baltimore today. The name "duckpin bowling" comes from a remark made by McGraw during the first game played with pins cut down from old standard pins. McGraw, an avid duck hunter, said that the flying pins looked like "a flock of flying ducks," and a sportswriter turned the remark into the word "duckpins."

In 1899, McGraw took over managerial duties while still playing for the Orioles; however, the team was eliminated from the National League, along with four other teams. McGraw followed through on a threat he made to abandon the National League and create an American League version of the Orioles, which he did in 1901. He managed the team from 1901 to 1902, until it was demoted to minor league status as a minor league franchise in the Eastern League, which would include a local and future baseball icon, Babe Ruth. Professional baseball would not return to Baltimore until the St. Louis Browns relocated to the city in 1954.

McGraw, meanwhile, moved to New York to become the manager of the New York Giants, which he would head up from 1902 to 1932, winning ten pennants, three World Series trophies and eleven second-place finishes. He ranks second all-time with 2,840 wins, and as a player, he was credited with helping to develop the hit-and-run, the Baltimore chop, the squeeze play and other strategic moves. He was inducted into the Baseball Hall of Fame in 1937 as a manager and is the subject of a book by Frank Deford entitled *The Old Ball Game: How John McGraw, Christy Mathewson, and the New York Giants Created Modern Baseball*, published in 2005.

McGraw's friend and neighbor was the aforementioned Wilbert Robinson, who purchased the home at 2740 St. Paul Street when it was completed in 1897. Robinson was a catcher for the Orioles and would later be manager of the Brooklyn Dodgers and inducted into the Baseball Hall of Fame. Robinson, born in 1863 in Bolton, Massachusetts, played for the Orioles from 1890 to 1899 and again with the American League Orioles in 1901. In 1892, he set a record by getting seven hits in a nine-inning game. When McGraw left to manage the New York Giants, Robinson took over managerial duties for the Orioles in 1902. In the 1910 census, Robinson was listed at 2740 St. Paul Street, along with his wife Mary and their daughter

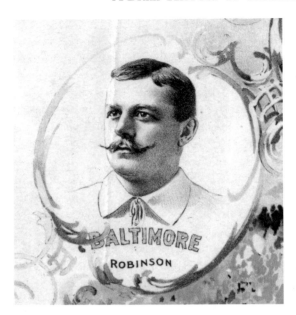

Orioles baseball player Wilbert Robinson lived next door to and co-owned an establishment with McGraw that is credited as being the birthplace of duckpin bowling. Both refused to leave Baltimore when several players were moved to Brooklyn. *LOC*

Hanna, son Wilbert Jr. and son Henry. Both Wilbert Sr. and Wilbert Jr. were then listed as owners of a saloon.

After serving as a coach for the New York Giants for his ex-teammate and close friend John McGraw, Robinson was named the manager of the rival Brooklyn Dodgers in 1914, a spot he would hold until 1931. He led the Dodgers to their first World Series appearances in 1916 and 1920. Robinson died in 1932 and was inducted into the Baseball Hall of Fame in 1945.

One block north of the famed Oriole players' homes, meanwhile, the view from the twenty-two houses that were built between 2801 and 2843 St. Paul Street beginning in 1896 would have overlooked a vacant block to the west for nearly eight years following their completion in early 1897 (the row of their counterparts on the west side of the block would not be built until 1905). Each was built at a cost of approximately $6,500 for Francis Yewell, who had hired William Wells for their construction.

By the time the 1900 census was taken, the east side row was occupied by a variety of professional workers and industry owners. They included merchant William Parrish and his family at 2801 St. Paul, plate glass manufacturer Edward Kaufman and his family at 2809 St. Paul, railroad clerk Louis Matthews at 2819 St. Paul, German native merchant John Steinbeck and his large family at 2821 St. Paul and German native druggist Henry Kluggel and his family at 2831 St. Paul.

A Neighborhood Takes Shape

The house at 2801 St. Paul was later home to the Fetting family, owners of the popular A.H. Fetting Jewelry store in Baltimore, who moved from a house at 2743 Maryland Avenue, where they were enumerated in the 1900 census. The business was begun by Anton H. Fetting in 1873 and was originally located at 14–18 St. Paul Street; after the great fire of 1904, it relocated to 213 North Liberty Street. Fetting was a director of both the German Bank and the German Fire Insurance Company in Baltimore and served on the Board of the Maryland Institute Schools of Art and Design, according to the book *Distinguished Men of Baltimore and of Maryland.*

Four houses down, civil engineer William Atwood and his family were the first owners of 2809 St. Paul Street. Atwood was one of the first presidents of the Peabody Heights Improvement Association and was elected the city surveyor in 1910, following a two-year stint as the "Commissioner of Opening Streets" that he undoubtedly could witness firsthand from his own house at the time. He was born on October 6, 1862, in Chester County, Pennsylvania, and was a graduate of the College of Philadelphia. He resided at 2809 along with his wife Carrie, whom he had wed in 1890, her mother Nellie and their daughter Helen. As did most of the families along the block in 1900, the Atwoods had a black live-in servant.

The same year that the bulk of the east side of the 2800 block of St. Paul Street was completed, several other blocks in Charles Village experienced a boom in residential development. In 1897, the four houses at 2601 to 2607 North Charles Street were built by Joshua Foreman at a cost of $1,500 each. Up the street, D. Cassard built a row of six homes between 2702 and 2712 North Charles Street that same year, while J.W. Sindall built the six houses between 2643 and 2653 Maryland Avenue and Joshua Foreman built the homes located at 2 to 10 East Twenty-sixth Street.

The housing surge in Charles Village in 1897 continued, as the four houses located between 2700 and 2706 St. Paul Street were constructed by Edward H. Hampson and sold for approximately $3,700 each. Hampson also built the houses at 32 to 42 East Twenty-seventh Street in 1897.

The street elevation of most of the row houses built in Charles Village at this time were composed of pressed brick, which was a more expensive and aesthetically pleasing finish than the simpler, cheaper common brick used in foundations, party walls and rear elevations. Their crude manner of production often resulted in rounded edges and larger mortar joints. Pressed bricks had sharper edges and could sustain smaller, thinner mortar applications. Since these pressed bricks required more refined production techniques and a higher degree of skilled labor, their purchase and installation

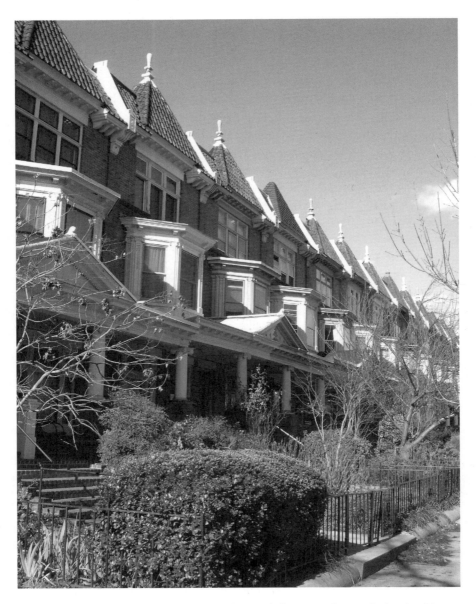

Those Charles Village homes built in the early twentieth century feature the iconic wide, connecting front porches that were a welcomed new architectural feature in Baltimore and remain an anomaly today.

was obviously more expensive. Thus, they were generally used for the most important elevation of a home.

Residential development in Charles Village slowed down in the late nineteenth century. In fact, after John T. Reed built the houses located between 26 and 40 East Twenty-fifth Street about 1890, the neighborhood saw no housing construction for eight years until Edwin H. Bennett Jr. and E.B. Hunting constructed six row houses located between 2522 and 2532 North Charles Street in 1898. Bennett also constructed the three homes one block north at 2625 to 2629 North Charles Street that same year; they sold for $3,000.

Bennett was born in Baltimore about 1872 and was then the owner of the Edwin Bennett Pottery Company, which began as the Chesapeake Pottery Company that his father had purchased in 1887. His large factory in Canton then employed five hundred people and consumed over eight thousand tons of clay and coal annually. They produced "opaque china wares of a high grade, among which were dinner, tea and toilet sets, jardinières, ferneries, and umbrella stands," according to Clayton C. Hall's *Baltimore: Its History and Its People*. Along with the company's subsidiaries, Edwin Bennett Pottery Company became one of the largest suppliers in the United States of hotel kitchen and tableware, chemical containers, public restroom fixtures and roofing tiles; the company shut down in 1936.

Despite an overall similar appearance in architectural design, upon a closer inspection, each home in Charles Village has its own distinct personality, such as this somewhat unusually placed porch.

Edwin Bennett and his three sisters, Emma, Alice and Bertha, were later enumerated at 2510 St. Paul Street in the 1920 census. Pieces produced in their Canton factory are occasionally found today at local antique shops and online auctions. Bennett built the three homes located between 2522 and 2526 St. Paul Street in 1907.

Although mostly razed, a row of homes located at 2612 to 2634 North Charles Street was also built in 1898 by G.F. Wilson for George A. Dubreuil, as were the houses located at 2631 to 2635 North Charles Street and the corner house at 2700 North Charles. The following year, the homes between 2517 and 2525 Maryland Avenue were constructed by W.T. King. They joined a row across the street that had been completed five years prior, but the remainder of the block would not be completed until 1911. J.W. Sindall built the six homes located between 2637 and 2647 North Charles Street in 1899, the same year that the house at 3–9 East Twenty-seventh Street was built.

At the close of the nineteenth century, architect J. Edward Laferty designed all of the row houses found on both sides of the 2900 block of St. Paul Street, which were built between 1899 and 1900. He designed the homes for builder Francis E. Yewell, starting with those located on the east side at 2901 to 2947 St. Paul, built in 1899. Each was constructed at a cost of about $6,000, double what homes were being sold for just the year prior. Beginning in the late 1910s, the large home at 2947 St. Paul Street was owned by Baltimore & Ohio Railroad passenger agent Charles W. Bassett and his wife, Mary. Charles had been born in Ohio in 1856, while Mary had been born in Iowa in 1862. Mary estimated the home's value in the 1930 census as an impressive $20,000, despite the onset of the Great Depression. The twenty-six homes located across the street, from 2906 to 2936 St. Paul, were built a year later, in 1900. Another B&O Railroad employee also lived in Charles Village. B&O Railroad conductor Albert David McCubbin and his wife Rose resided at 202 West Twenty-fifth Street, where they were enumerated in the 1930 census. McCubbin was born in August 1875 in Pennsylvania, and he and his wife lived at number 202 along with their son Albert Jr., a brakeman for the railroad, and daughters Dorothy and Helen. They had moved from a rented house located on Twenty-fourth Street. Their new house on Twenty-fifth Street was then valued at $3,500, and the family was able to afford a live-in white domestic servant named Eva Hall. Considering the B&O Railroad's significant presence in Charles Village, it's not surprising that several B&O executives and employees resided in Charles Village.

Those houses built in 1899 along the east side of the 2900 block of St. Paul Street were fully inhabited by the time the 1900 census was enumerated

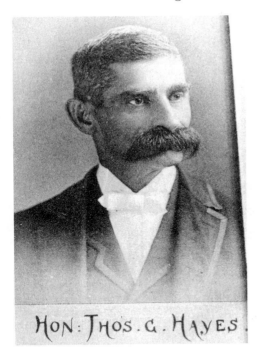

HON: THOS. G. HAYES.

Baltimore mayor Thomas G. Hayes resided at 2901 St. Paul Street as mayor in 1900, one of many prominent residents who sought a new suburban lifestyle. *From* The Monumental City, *1894.*

in June of that year. Among the first owners was the then mayor of Baltimore City, Thomas G. Hayes, who purchased 2901 St. Paul upon its completion in 1900. That sale was undoubtedly a coup for builder Frances Yewell that added credibility and prestige to his emerging Peabody Heights developments. Hayes lived there along with his sister Julia, a schoolteacher, and a live-in, Irish-born servant named Anna Houghton, who had immigrated in 1868. According to the 1900 federal census, Julia Hayes was born in November 1869 and was unmarried. The houses between 2708 and 2712 St. Paul were also built in 1900.

Hayes, the son of the Reverend Thomas Chilton Hayes and Juliana Gordon, was born on January 5, 1844, in Anne Arundel County. He was attending school in Alexandria, Virginia, when the Civil War began in April 1861, and he enlisted in the Alexandria Riflemen, which subsequently became part of the Seventeenth Virginia Infantry Regiment. In late 1861, he resigned from the army and entered the Virginia Military Institute (VMI) on January 1, 1862. Hayes participated in the Battle of New Market on May 15, 1864, as a cadet corporal in Company B. He graduated from VMI on July 4, 1867, standing fifth in a class of eleven.

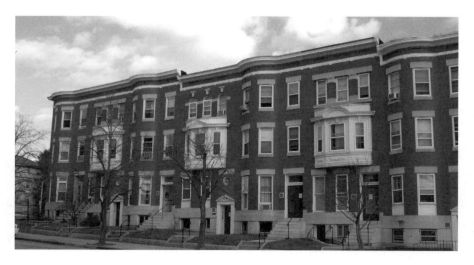

The homes in the 2700 block of North Charles Street predate the more typical large front porches found throughout Charles Village and feature more traditional bay windows.

Following graduation, Hayes taught at the Kentucky Military Institute for four years, where he also studied law. In 1872, he returned to Baltimore and opened his own law practice. He was elected to the Maryland legislature in 1879 and served as mayor of Baltimore from 1899 to 1903. A lifelong bachelor, Hayes died at Oakland, in Garrett County, Maryland, on August 27, 1915.

Other early prominent residents of the 2900 block of St. Paul Street included William R. Barnes and his family at 2925. Barnes was born in Baltimore on Halloween 1864 and graduated from law school at the Baltimore University. In 1885, he married Lillian L. Peat, whose father William Peat, a building contractor specializing in stone, was responsible for the construction of many Johns Hopkins University buildings and the large addition to the Peabody Library.

The 1910 census listed the occupations along the 2900 block of St. Paul Street, including a stockbroker, manufacturer, insurance agents, cleaning company owner and the president of a marble company.

1900–1909: RISE OF PROMINENT BUILDERS

As on several blocks during the early building phases of the neighborhood, those who purchased the homes in the completed row on the east side

of the 3000 block of St. Paul Street in 1901 would enjoy an open view across the street for nearly six years before the west side of the block was developed. John S. Moke built the homes located between 3001 and 3047 St. Paul beginning in 1900 and sold them for about $6,500 each upon their completion the following year. The opposite side of the block was developed between 1907 and 1911. Also built in 1900 were the three houses between 2708 and 2712 St. Paul Street and those located between 386 and 398 East Thirty-first Street.

While significant row house development continued in Charles Village, an unusually wide, grand home was built on St. Paul Street. The individual house at 2938 St. Paul Street was designed in 1900 by architect J. Edward Laferty for owner Robert Regester, who was born about 1859 in Maryland, according to the 1910 census that was taken at the house. Retired, he lived there along with his wife Virginia, also a native of Maryland, whom he had wed in 1873. Their grown son Robert Jr. and his wife Nellie also lived in the house, along with their daughter Elizabeth, their grown son Wilson and his wife May and their daughter Katherine. Both sons worked as salesmen.

The extended Regester family was tended to by a mulatto servant named Lenore Fleet, enumerated in the 1910 census as a forty-year-old native of Maryland. Census enumerators that year were instructed "to be particularly careful in reporting the class mulatto. The word here is generic and includes quadroons, octoroons and all persons having any perceptible trace of African

Robert Regester had 2938 St. Paul Street built as an individual house. Today, the Sigma Alpha Epsilon fraternity of Johns Hopkins University occupies the home, one of a few fraternities located in Charles Village. *From* History of Landmark Lodge, *1911.*

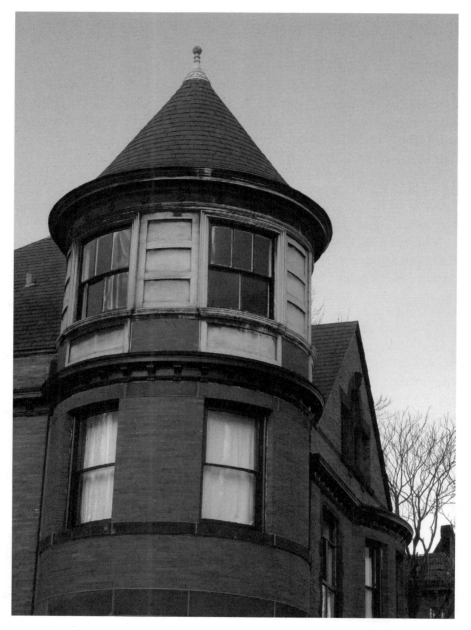

The impressive mansion at 2900 North Calvert Street was home to Dr. Merville Carter. The 1901 home features a copper-clad turret and cost $30,000 to construct.

blood." Importantly, it was up to the census taker to observe and determine race, not the subject being interviewed, which often led to misrepresentations in race.

The house is currently owned by the Sigma Alpha Epsilon fraternity of Johns Hopkins University and was the scene of a murder in April 2004, when a man entered the fraternity house and stabbed a twenty-year-old student from Camden, South Carolina, who died the next day. The murder prompted neighborhood and Johns Hopkins University security to beef up security efforts, including the installation of a closed-circuit camera system.

While the home at 2938 St. Paul Street is grand, the imposing mansion at 2900 North Calvert Street stood by itself along the entire 2900 block for four years following its completion in 1901. It was also designed by J. Edward Laferty for Dr. Merville Carter and his family and was built at a cost of over $30,000, including land costs, an extraordinary amount for the time period and for Charles Village. It features Laferty's trademark use of thin, Roman-style brick, with a three-story turret at the corner, faced in copper and roofed in slate. The Carters moved into the house in 1901 from a prior address at 1800 West Baltimore Street. According to the 1900 federal census for Baltimore City, they lived there along with Dr. Carter's younger brother James, a drugstore clerk who was born about 1877.

Dr. Carter had made a small fortune from his ownership of the Resinol Chemical Company, located at 517 West Lombard Street, makers of the popular Resinol soap and other sundries that were advertised throughout the country at the time he built 2900 North Calvert Street. He was born on August 21, 1857, in Middletown, Virginia, the son of Dr. James P. and Mary S. Carter, part of an early American lineage that included his grandfather Thomas, who had fought in the War of 1812. Carter studied chemistry at the Virginia Polytechnic Institute, followed by an apprenticeship in medicine under his father. He later attended the College of Physicians and Surgeons of Baltimore, from which he received his medical degree on March 6, 1878.

On May 20, 1880, Carter married Emma Shephard Gold of Winchester, Virginia, who was described in 1912 as "a woman of gracious personality, who combines the domestic virtues of the ideal wife and mother with the brilliant social qualifications of a popular hostess," according to Hall. They had two children together, Henry Leroy, born in August 1883, and Julian Gold, born in May 1889.

Dr. Carter established his own medical practice while he also served as a visiting physician at the Hebrew Orphan Asylum from 1885 to 1900. *From* Baltimore: Its History and Its People, *1912.*

After practicing medicine in Virginia for five years, Carter returned to Baltimore in 1884 to establish his own medical practice, while he also served as a visiting physician at the Hebrew Orphan Asylum from 1885 to 1900. His combined medical and chemical training led to the formation of the Resinol Chemical Company in 1895, "which has long been a monument to his executive ability and progressive spirit," according to Hall. Carter also served as the director of the Drovers' and Mechanics' Bank and the Westport Paving Brick Company, where his son H. Leroy served as secretary.

The 1920 census lists Carter at 2900 North Calvert Street as a widower, living there along with his two sons, Julian and H. Leroy, and H. Leroy's wife Virginia, who had three children between the ages of one and eight. He also housed Emma's sister, Margaret A. Gold, and a fifty-year-old boarder named Mary B. Johnson. The entire family was tended to by a widowed black servant named Georgianna Butler, who was born in Virginia about 1874. Dr. Merville Carter died in the house on September 5, 1939.

One block south of the Carters' grand home, builder Francis E. Yewell constructed the entire west side of the 2800 block of North Calvert Street in 1902. The homes located between 2800 and 2846 North Calvert Street

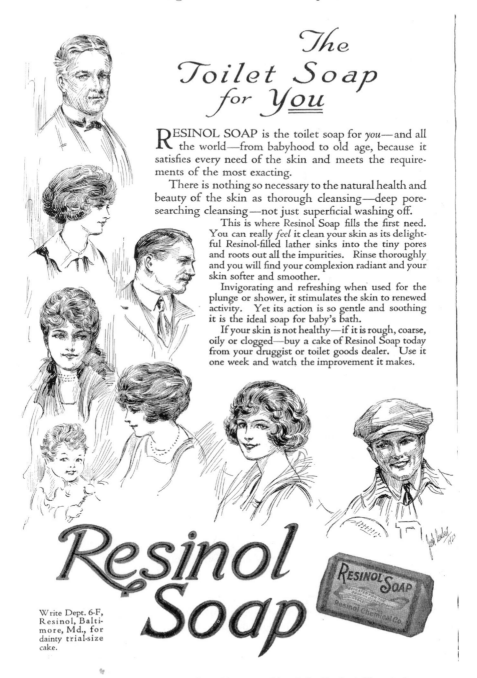

The Toilet Soap for *You*

RESINOL SOAP is the toilet soap for *you*—and all the world—from babyhood to old age, because it satisfies every need of the skin and meets the requirements of the most exacting.

There is nothing so necessary to the natural health and beauty of the skin as thorough cleansing—deep pore-searching cleansing—not just superficial washing off.

This is where Resinol Soap fills the first need. You can really *feel* it clean your skin as its delightful Resinol-filled lather sinks into the tiny pores and roots out all the impurities. Rinse thoroughly and you will find your complexion radiant and your skin softer and smoother.

Invigorating and refreshing when used for the plunge or shower, it stimulates the skin to renewed activity. Yet its action is so gentle and soothing it is the ideal soap for baby's bath.

If your skin is not healthy—if it is rough, coarse, oily or clogged—buy a cake of Resinol Soap today from your druggist or toilet goods dealer. Use it one week and watch the improvement it makes.

Resinol Soap

Write Dept. 6-F, Resinol, Baltimore, Md., for dainty trial-size cake.

RESINOL SOAP
Resinol Chemical Co.

Dr. Carter had made a small fortune from his ownership of the Resinol Chemical Company, makers of the popular Resinol soap and other sundries that were advertised in popular ladies' magazines of the era.

were the first to have the familiar porch that denotes a Charles Village house today. The opposite side of the street was built in multiple phases, beginning in 1905, but it was completed in its entirety by 1915.

Meanwhile, architect George Clothier designed houses on the southern portion of the 2600 block of Maryland Avenue in 1904 that included those located between 2601 and 2611 on the east side and 2600 to 2608 on the west side of the street; they were constructed by Charles B. Burdette. Those homes from 2646 to 2654 Maryland were also constructed in 1904. This block was once home to a Civil War encampment called Camp Bradford (see Chapter One).

The following year, 1905, architect Jacob F. Gerwig provided plans for the eight houses to be built from 2527 to 2541 St. Paul Street by John F. Moke. Jacob F. Gerwig, who was a self-taught architect, constructed many homes in Charles Village. Gerwig was born in December 1857 in Howard County, Maryland, and according to the *City Directory*, by 1890 he had made his way to Baltimore City and was working as a carpenter while living at 2332 Barclay Street, just south of what would become Peabody Heights. He listed his profession as a builder in the 1900 census, when he and his wife Mary resided at 2906 Walbrook Avenue in Baltimore City. They had married about 1885 and had eight children together—Charles, Mary, Florence, Ada, William, Ruth, Harry and Kenwald Gerwig. By 1910, Gerwig had graduated from builder to architect/designer with his own office, having, during the previous decade, designed many of the houses found in Charles Village that are noted for their fine interior wood detailing. He and his family then resided at 1028 North Fulton Street in Baltimore City. His son, William Gerwig, born in 1897, followed in his father's footsteps and also became an architect beginning about 1920.

The year 1905 brought a significant amount of development in Charles Village. Builder Henry E. Cook constructed the nine homes located between 2619 and 2635 St. Paul Street that year, while George C. Thomas built those located between 2636 and 2644 North Charles Street to the designs of architect George Clothier.

Also in 1905, a full eight years after the east side of the 2800 block of St. Paul Street had been constructed by William Wells, the west side of the street was developed by the Charles E. Spaulding Company. The new homes, located between 2800 and 2844 St. Paul, were sold at $8,000 and were designed by Jacob F. Gerwig and built by his brother, Charles H. Gerwig. The two brothers would team up again on the east side of North Calvert Street for the two rows of homes located from 2801 to 2811 and 2819 to 2841.

Peabody Heights

FINEST SECTION OF THE CITY.

15 LEFT OUT OF 75

3000 Block **Guilford Ave.**

WEST SIDE.

PRICE $5,250, IN FEE

Three-story, stone porch front. 8 rooms, reception hall, bath and pantry, with every conceivable convenience, including modern steam heating system. Lot 16x154 to 20-ft. alley. Terms to suit. Apply on premises.

GEO. A. COOK.

OWNER AND BUILDER.

Builders of Charles Village homes advertised their newly completed projects, strategically highlighting the large lot sizes, large front porches and other features not found in other neighborhoods in Baltimore at the time.

The front façade of many of the row houses built in Charles Village after 1905 is composed of a material coined iron spot brick, a much harder brick than the locally produced soft red brick, which was so porous that most of it was soon covered with paint or, later, Formstone. The mustard-colored iron spot brick was produced from the high-iron-content clay from western Pennsylvania, which produced a bleeding pattern on the surface when kiln-dried at high temperatures.

At the southwest corner of St. Paul and Twenty-ninth Street lived John P. Stone, president and founder of Maryland Casualty Company, which opened in 1898 with only seven employees. Its first policy was to insure the elevators in the home office of the Baltimore & Ohio Railroad, and its offices were in the Keyser Building. Luckily, Stone was able to evacuate all of his employees and fourteen wagons full of records when the Great Baltimore Fire struck their offices in 1904. His business prospered and would eventually include offices in Canada and Mexico and dealings in Cuba and Panama. The company eventually moved its offices to the neighborhood of Hampden, today the site of the Rotunda Shopping Center.

The house at 2840 St. Paul Street was the home of Maryland governor Herbert Romulus O'Conor (1896–1960), the fifty-first governor of Maryland, serving from 1939 to 1947. He also served in the United States Senate, representing Maryland from 1947 to 1953. O'Conor was born in Baltimore to James P.A. O'Conor and Mary A. (Galvin) O'Conor. He received his BA degree from Loyola College and graduated from the University of Maryland School of Law in 1920. While in school, O'Conor was a reporter for the *Baltimore Sun* and the *Evening Sun* from 1919 to 1920.

On November 24, 1920, he married Mary Eugenia Byrnes (1896–1971), and together they had five children: Herbert R. Jr., Eugene F., James Patrick, Robert and Mary Patricia. Tragically, his secretary, Camilla Conroy, died in the burning of the luxury liner SS *Morro Castle* in 1934.

Meanwhile, between 1905 and 1907, the two sides of the 2900 block of North Calvert Street were constructed. The eighteen row houses located between 2902 and 2934 were built by James T. Miller in 1905, just north of the Dr. Carter mansion, and the home at 2910 North Calvert Street was once the home of famed local sculptor and art advocate Mary Ann Mears. The pair of houses at 2915 and 2917 was built a year later to the designs of architect John R. Forsythe, the same year his seven designed homes between 2925 and 2937 Calvert Street were constructed by James Miller. They were completed in 1907.

William Groscup served as the builder for Forsythe's next designs on the street, located between 2901 and 2907, which were built in 1907 at a cost of approximately $12,000 each, double what homes were built for just eight years prior. Forsythe also produced the plans in 1906 for the Peabody apartments built in this block. The 1920 census listed the occupations of residents along the 2900 block as the owner of a wallpaper company, several treasurers and salesmen, a draftsman, a bookkeeper and a government auditor.

In 1906, the west side of the 2500 block of North Calvert Street (2501 to 2525 North Calvert Street) was developed to the designs of Jacob F. Gerwig, who also designed those across the street (located between 2506 and 2532 North Calvert Street) that were built beginning late in 1906 and featured Baltimore's signature white marble steps. The house at 2523 North Calvert Street was also home to a famous local artist, Wasyl Palijczuk, a Ukrainian-born sculptor, painter and professor at McDaniel College in Westminster, Maryland. Palijczuk's story of survival in Nazi Germany, living alone as a child after his father was arrested and his immigration to the United States and eventually to Baltimore, where he thrived as an artist, is inspiring. His first true home, he says, was the one he moved into in Charles Village during the Baltimore riots of 1968.

Jacob F. Gerwig continued his residential development on the west side of the 2600 block of North Calvert Street with the design for the homes located between 2601 and 2647, which were built in 1906 by the Land Improvement Company and builder Henry E. Cook. Their counterparts across the street were designed and built a little more than a year later by different individuals. Maryland Avenue also witnessed a boom in 1906 with the construction of the row of homes between 2615 and 2627

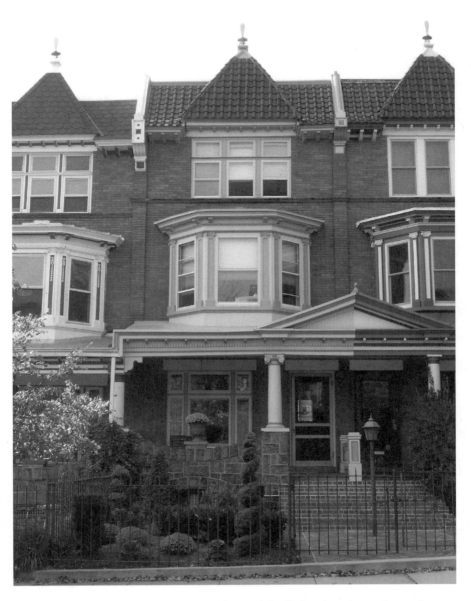

Many homeowners today embrace the architectural details found on the row houses by applying a fanciful palette of colors while also taking advantage of the mandated twenty-foot setback that provides landscaping opportunities.

Maryland Avenue that were built in 1906 by George C. Thomas to the designs of George Clothier. The row joined others on the block that had been built as early as 1895. A block north, the homes located between 2721 and 2753 Maryland Avenue were built beginning in 1906 by Charles B. Burdette and designed by Jacob F. Gerwig. The pair also had joined together to develop the opposite side of the street in 1906 to build those houses between 2700 and 2726 Maryland. The home at 2710 Maryland Avenue was once the home of famous medievalist, etymologist, philologist and literature professor Kemp Malone, who taught at Johns Hopkins for thirty years. The English department's library at Emory University bears his name.

Charles Village's evolution continued throughout 1906 with the building of the houses located from 1 to 5 West Twenty-seventh Street, as well as the pair of homes located at 2843 and 2845 North Calvert Street; the latter was once the home of Gustav Strube (1867–1953), the founding conductor of the Baltimore Symphony Orchestra, serving from 1917 to 1930. Strube was a German-born conductor and composer who also taught at the Peabody Conservatory. He also wrote an opera, *Ramona*, which premiered in 1916.

While Charles Village's exterior architecture and glorious Painted Ladies garner much attention, the interiors of these homes were no shrinking violets. Meticulous hardwood floors, striking front doors with beveled glass, imposing pocket doors separating the parlors and the formal dining rooms and dramatic curved staircases highlighted the first floors, while smaller servants' stairs in the kitchens allowed live-in servants to go between the first and second floors without disturbing formal gatherings in the parlor areas. Kitchens located in the rear of the first floors allowed for ice delivery in the rear of the house, while upper floors contained as many as five bedrooms and multiple bathrooms. The front receiving rooms in many Charles Village homes—including those in the 2600 block of Guilford Avenue—contain faux fireplaces, complete with dramatic mantels, presumably because these homes were built shortly after the Great Baltimore Fire of 1904. Another interesting feature found in many Charles Village row houses is a mysterious hole in brick walls. During their construction phase, adjoining row houses often had holes in the brick party walls for workers, materials and tools to pass through while they performed the same job in each house without having to exit the house. The holes were bricked in during the final stages, but the arched brick lintels often remain in the houses today, visible on any exposed brick walls.

A Neighborhood Takes Shape

While some row houses built during the grand building boom of the early twentieth century have lost some of these exquisite interior features—mostly during conversion from single-family homes to multi-unit apartment buildings—many still retain their original appearances, allowing today's homeowners a peek into a different era.

While 1906 signifies one of the most important years in the residential development of Charles Village, 1907 was not to be outdone, as the building boom that began in 1906 continued the following year. The three homes located between 2522 and 2526 St. Paul Street were built that year by Edwin H. Bennett Jr., who had retained the architectural firm of Cromwell and Holmes for their design. Bennett had previously constructed several homes between 1898 and 1899 in the 2500 block of North Charles Street, near his large country estate house.

Two blocks east, both sides of the 2500 and 2600 blocks of Guilford Avenue were built in 1907 and were designed by architect Jacob F. Gerwig, while builders Joseph Pentz and Frank O. Singer were responsible for their construction. Each of the homes originally featured a pair of whimsical plaster faces embedded into opposite walls of the entry vestibule, many of which remain to this day. Gerwig also designed the houses from 2632 to 2644 Maryland Avenue in 1907.

On the east side of Guilford Avenue, meteorologist William H. Alexander and his family owned 2627 Guilford Avenue in 1910, while Irish immigrant and retired lace importer Richard Cochran and his German-born wife Augusta owned the house next door at 2629 Guilford. The home at 2635 Guilford Avenue was owned by German immigrant Henry Stegman, a bookkeeper in a brewery who had come to the United States in 1870. He lived there along with his wife Anna, their six children and a boarder. Other occupants along the block worked as a butter merchant, insurance salesman and schoolteacher.

On the west side of the block, haberdashery manager John A. Welsh lived with his family at 2630 Guilford, while engraver Samuel S. Kirby lived with his family at 2636 Guilford, not far from John Naulty and his family at 2646 Guilford, who indicated that he worked as an "exterminator of insects" in the 1910 census. Also built in 1907 was the long row of homes on the east side of North Calvert Street located between 2600 and 2646 that was designed by Philadelphia architect J.C. Fernald and built by Henry E. Cook. These homes were sold for approximately $6,500 each upon completion. Additionally, the nine homes located between 2719 and 2735 North Charles Street were built in 1907 at a cost of approximately

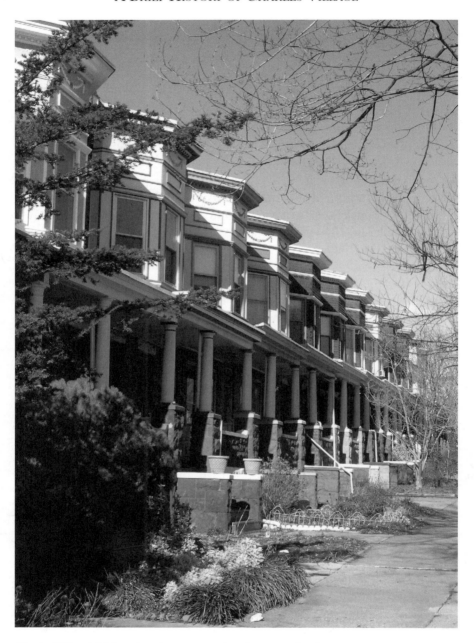

Charles Village's higher elevation compared to downtown Baltimore was enticing to early homeowners, as was the affordability as a result of ground rent.

$10,000 each by James T. Miller. The houses located between 101 and 107 West Twenty-seventh Street were built by Charles B. Burdette to the designs of Jacob Gerwig.

Several small building projects occurred along the west side of the 3000 block of St. Paul Street in 1907; the pair at 3002 and 3004 was built by John R. Fountain and the pair at 3006 and 3008 was built by John S. Moke to the designs of Jacob Gerwig, who also provided the plans for those located between 3010 and 3016 built that year. St. Paul Street's massive development in 1907 continued with the building of 3042 for Mrs. Charles B. Kriel at an impressive cost of $10,000.

Residents of Charles Village witnessed further construction the following year, as both sides of the entire 2700 block of North Calvert Street were built in 1908, designed by two different architects. Jacob F. Gerwig designed those on the east side of the street located between 2701 and 2745 North Calvert, which were built by George A. Cook. Builder Henry E. Cook constructed

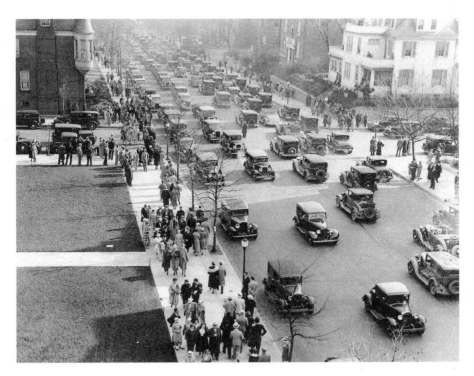

Originally a suburban area accessed primarily via horsecars and streetcars, Charles Village quickly became a commuting suburban area with the onslaught of the automobile. Few today could envision four-lane streets in Charles Village. *P&J*

those across the street at 2700 to 2746 North Calvert Street, which had been designed by architect J.C. Fernald.

Most of the homes built in this building boom in Charles Village feature a unique local stone. The Hummelstown stone trim and first-floor porch foundations found on many of the homes in Charles Village originates from the western end of the Lebanon Valley in Pennsylvania, ten miles east of Harrisburg, in the small town of Hummelstown, which became the site of one of the outstanding brownstone industries in the United States. German settlers in the area first recognized the value of this stone as a building material, and on May 2, 1867, the Pennsylvania Brown Free Stone Company was formed. In 1875, it was bought by Allen Walton, who continued with the corporate name until 1891, at which time he had it rechartered as the Hummelstown Brownstone Company. Walton aggressively sought markets in Washington, D.C.; Baltimore, Maryland; and Richmond, Virginia.

In 1885, the Hummelstown Brownstone Company built and chartered the Brownstone-Middletown Railroad, a standard-gauge rail line that joined the Reading Railroad at the east end of Hummelstown. This improvement

Hummelstown stone from nearby Pennsylvania is quite prevalent in Charles Village, as its superior durability replaced early uses of brownstone, which was susceptible to the elements.

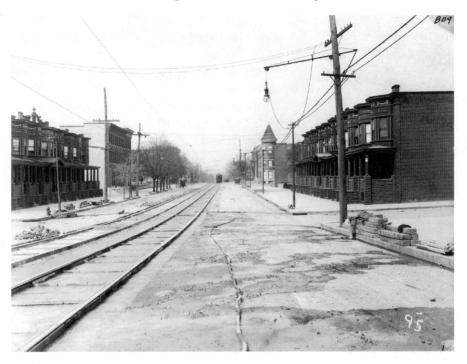

This vintage 1915 photo at the intersection of Twenty-fifth Street and Guilford Avenue looking west represents the street conditions of the era and the crude early attempts at street lighting. *MHS*

increased sales tremendously. Many quarries were solely suppliers and purveyors of the stone, and few were involved in the finishing phases or the elaborate process of stonecutting; rather, this was done by another company. The Walton firm was the exception, as it chose to handle all aspects of production and finishing, thereby enabling it to compete more profitably in the market.

A rock-face finish (sometimes called pitch-faced work) was done with the pitching chisel and the face of the stone left rough. This finish required little work and was cheaper than any other kind. The tooth-chisel finish resembled pointed finishes, but it was not so regular. Broached work was done with a point so as to leave continuous grooves over the surface, and crandalled work, which gives the stone a fine, pebbly appearance, was done with a crandall, which looked much like a large comb. Most bas relief and shallow sculptural forms could be visualized from the architectural rendering or drafting and carved into the stone, but if the shape was more complex, a three-dimensional, plaster-of-Paris model

was sometimes made to see how the precise form would appear and to act as a guide for the stonecutter.

Meanwhile, in 1909, the row of homes located between 2923 and 2943 North Charles Street was designed by architect John R. Forsythe and built by James T. Miller. These homes were sold for approximately $15,000 each upon their completion. Farther north, the house at 3001 North Charles Street was built in 1909 for owner John Hubert, while the twelve houses located between 3000 and 3022 North Calvert Street were designed by architect John R. Forsythe and built beginning in 1909. One block north, the majority of the southern portion of the 3100 block of Calvert Street was built in 1909 by the Owners Reality Company, which built those on the west side at 3100 to 3116 and those on the east side between 3101 and 3117. The northern portion of the block was developed later and in two stages, in 1914 and 1918.

1910–1925: A NEIGHBORHOOD TAKES SHAPE

In 1910, the northern areas of North Charles Street continued to grow. The house at 2901 North Charles Street was built by Ignatius Smith for Mrs. M.S. West; it currently serves as the Unity Center of Christianity. Farther north, 3301 North Charles Street was built in 1910 as a private residence for Grafflin and Charlotte Mallory Cook and their only son, Grafflin Jr. It was designed by architect Joseph E. Sperry and was valued at an impressive $25,000 in 1930, despite the Great Depression. Grafflin Cook Sr. was born in Baltimore on November 17, 1869, and owned a successful undertaker and manufacturing business at 1002 Lafayette Avenue.

The following year, 1911, architect J. Appleton Wilson and builder George A. Blake partnered once again to complete a row of houses in the 2500 block of Maryland Avenue, constructing those at 2518 to 2530. The row of thirteen houses located between 2728 and 2752 Maryland Avenue was built by Edward J. Gallagher, who also built a row of homes on the block to the north the following year and began building the houses between 100 and 126 West Twenty-seventh Street that were completed in 1912.

The houses located between 5 and 19 West Twenty-ninth Street were designed by John R. Forsythe and built in 1911 by James T. Miller; each was advertised at $9,500 when completed. Also built in 1911 were the eleven houses located between 3020 and 3040 St. Paul Street by James T. Miller to the designs of architect John R. Forsythe.

A Neighborhood Takes Shape

The house at 3034 St. Paul Street was the home of Otto Rudolph Ortmann, musician, teacher, composer, theorist and leader in both experimental music and instruments. He spent his professional life rather obsessed with finding the right manner in which to play the piano. He was a 1917 Peabody Conservatory graduate, a member of its faculty (in harmony and piano) from 1917 to 1928 and then took over as the head of the conservatory. In 1929, he published a 375-page book titled *Physiological Mechanics of Piano Technique*, in which he outlined a theory of musical experience, developing aspects of the physics of sound, qualitative theory and Gestalt psychology. Ortmann became a scientist of piano playing, established a laboratory at Peabody and set out to study and measure every aspect of making music at the keyboard.

Housing construction in 1911 continued to flourish with the construction of 3001 and 3023 North Calvert Street by architect John R. Forsythe. Farther east, on Abell Avenue, both sides of the 3000 block were built by the Abell Building Company beginning in 1911. Architect Stanislaus Russell designed all of the homes located at 3001 to 3051 and 3000 to 3050 Abell Avenue.

Following the apartment expansion in Charles Village in 1911 (see Chapter Four), architect Jacob F. Gerwig and builder George A. Cook, who were both responsible for a significant amount of construction in the neighborhood over the years, built the houses on the west side of Guilford Avenue between 2800 and 2848 in 1912. They were sold for approximately $5,200 upon their completion late that year. Gerwig and Cook teamed up again in 1912 to develop the row of houses located at 2900–2944 Guilford Avenue on the east side of the block. They were marketed at $5,200 when completed later that year. The opposite side of the 2900 block was not developed until 1914.

Other developments in 1912 include Edward J. Gallagher's construction of the homes located between 2800 and 2836 Maryland Avenue (they were finished in 1913) and the large and rather unusual houses on North Calvert Street between 3025 and 3043, designed by John R. Forsythe. The builder filed for bankruptcy during construction, however, and the houses were purchased by George Morris and converted into the Gilman Apartments in 1913.

Another notable construction project in 1912 was the entire east side of the 3000 block of Guilford Avenue, built by John P. Brandau and designed by architect A.F. Blatchley. The opposite side of the block would not be built until 1914.

Nearby, architect Stanislaus Russell designed the houses located on East Thirty-first Street from 307 to 317 and 329 to 339 that were built in 1912 by

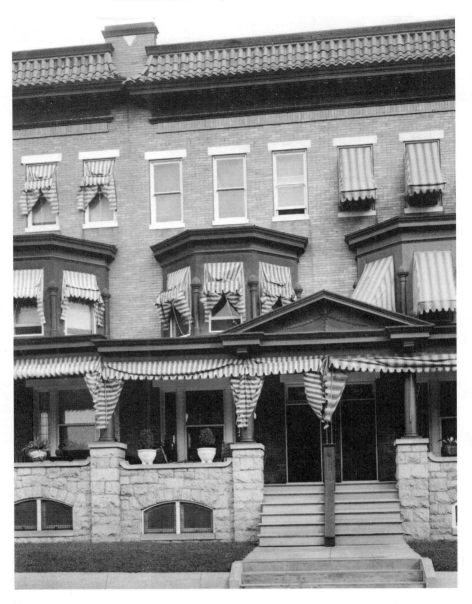

This image of the 3100 block of Guilford Avenue shows how homeowners used canvas awnings to block the sun's harmful rays and keep homes cool before the onset of air conditioning. *EPFL*

the Abell Construction Company, which also constructed the homes located on the east side of the 3100 block of Abell Avenue, located from 3101 to 3145. Across the street, the houses at 3100 to 3144 Abell were built that same year by Edward J. Storck following the designs of Jacob F. Gerwig. One block north, the east side of the 3200 block of Abell was also constructed that year, with the homes located between 3201 and 3247 designed by Jacob Gerwig and built by Henry E. Cook. The opposite side of the block would not be constructed until 1914. This period represents some of the most significant construction on and around Abell Avenue.

Close to the Abell Construction Company's work on Thirty-first Street in 1912, architect Frederick E. Beall designed homes located at 200–202 and 300–310 East Thirty-first Street in 1913, which were constructed by Edward J. Storck. Beginning late that year, Johns Hopkins University's Gilman Hall at 3400 North Charles Street was designed by the architectural firm of Parker, Thomas and Rice and constructed between 1913 and 1914.

Charles Village's residential landscape was altered dramatically in 1914. The nine houses between 2500 and 2516 Maryland Avenue were built that year to the designs of architect J. Appleton Wilson and constructed by builder George A. Blake. The houses located between 2627 and 2641 Howard Street were also built in 1914 by Edward J. Gallagher, who built all of the houses along the block to the north three to five years later. Architect Jacob F. Gerwig continued to be a design influence along Guilford Avenue when he again teamed with builder Frank O. Singer to develop the entire 2700 block of Guilford Avenue in 1914, just as they had done to the entire two blocks south seven years earlier. Gerwig and Cook also partnered that year to design and build the homes located between 3000 and 3048 Guilford Avenue.

The 3000 block of Guilford Avenue in 1912 foreshadows how today's new planned communities construct homes in previously rural areas with homes being built simultaneously as a cost-saving measure. *EPFL*

The house at 2718 Guilford Avenue was the childhood home of bass-baritone singer and actor Earl Cranston Wrightson (1916–1993). He is perhaps best known for hosting his own television show on CBS between 1948 and 1952 and for making guest appearances on Michael Douglass's and Johnny Carson's talk shows and the *Bell Telephone Hour* show in the early 1960s. In 1962, he was featured with Lois Hunt and Mary Mayo on the recorded soundtrack to *Kiss Me Kate*.

The homes at 2801–2831 Guilford Avenue on the east side of the street were also built in 1914 to the designs of architect J.C. Spedden and constructed by builder H. Webster Cooke. Spedden and Cooke also partnered that year to develop the east side of the 2900 block of Guilford Avenue, houses located between 2901 and 2935.

Other developments in 1914 include the homes located between 3125 and 3143 North Calvert Street, which were not sold until late 1915 and 1916 by James T. Miller, and the west side of the 3200 block of Abell Avenue, from 3200 to 3246, designed by Jacob F. Gerwig and built by Edward J. Storck.

Houses constructed in 1915 include the three homes at 2813 to 2817 North Calvert Street by A.W. Stehlman, which were constructed in the southern yard of an individual house at 2819 Calvert that had been built ten years prior. The Abell Building Company also constructed the houses located between 307 and 317 East Thirtieth Street in 1915, while those at 319 to 343 East Thirtieth Street were built that same year by John P. Brandau.

Jacob F. Gerwig and Edward Storck's partnership continued in 1916 when they designed and built the southern portion of the east side of the 3100 block of Guilford Avenue, the homes located between 3101 and 3119. They would build the northern portion of the east side and houses on the west side of the block two years later in 1918. Also built in 1916 was the house at 3109 North Charles Street, designed by architect Oliver B. Wright for Mrs. Sarah B. Owen, and the homes located between 201 and 229 East Thirty-third Street by John J. Kirkness.

Over on Howard Street in 1917, Edward J. Gallagher constructed the homes located between 2701 and 2737. He also completed those across the street two years later. The E.J. Gallagher Realty Company was incorporated in June 1909 and became active in January 1915. Its founder, Edward Joseph Gallagher (1864–1933), however, was a builder who had been constructing houses in Baltimore since the 1880s. The son of Irish immigrants, his first venture was in Canton, where he built on two lots he had obtained in exchange for ground rent from the Canton Company in July 1888. By that October, he had sold both of the two-story Italianate houses for

A Neighborhood Takes Shape

$1,350, realizing a profit of nearly $500 for only four months' work. His timing was perfect, as thousands of immigrants and factory and industrial workers moved to the city in search of steady work. Over the next fifty years, Gallagher would construct over four thousand dwellings, primarily for the working and middle classes.

Jacob F. Gerwig and Edward J. Storck designed and built the houses located between 301 and 323 East Thirty-third Street that same year, and in 1918, the two designed and built 3121 to 3133 Guilford Avenue, adding the north portion of the block that they had built two years prior, and the west side of the block between 3120 and 3132 Guilford Avenue. Jacob F. Gerwig teamed up with builder Frank O. Singer for the houses between 3118 and 3122 North Calvert Street.

Also in 1919, Edward J. Gallagher completed the 2700 block of Howard Street by constructing those homes located on the west side at 2700 to 2736, adding to the east side that he had constructed two years prior. Also built that year was the house at 3211 North Charles Street, designed by architect Clyde N. Friz; 100–108 and 101–109 East Thirty-first Street; 101–109 East Thirty-third Street; the west side of the 3200 block of North Calvert Street (3200–3212) by Jacob F. Gerwig and Frank O. Singer; and 200–208 and 201–205 East Thirty-first Street by Jacob F. Gerwig and Edward J. Storck. In 1921, 301 East Twenty-ninth Street was built, and architect Jacob F. Gerwig and builder Edward J. Storck partnered to design and build all of the homes on the west side of the 3200 block of Guilford Avenue, those located between 3200 and 3220. They would complete the opposite side of the block a year later.

Additionally, in 1922, Jacob F. Gerwig and Edward Storck designed and built 3201–3221 North Calvert Street, a row featuring an unusual configuration with three-story apartment units at each end of the individual row houses. Their exterior details are much simpler than those Jacob F. Gerwig designed just fifteen years earlier in the 2600 block of Guilford Avenue—for example, expressing the changing aesthetics from heavy Victorian detailing to a more streamlined design. The two also completed the homes on the east side of Guilford Avenue between 3201 and 3221. The only other development in 1922 was the construction of the homes at 2800–2814 Howard Street.

Charles Village today is home to a row of shops, bars and restaurants that line the east side of the 3100 block of St. Paul Street and were originally constructed as private homes about 1923. That same year, those homes located between 2801 and 2833 Howard Street were constructed.

As a testament to the architectural diversity and the individual flair of the numerous builders of Charles Village homes, some homes feature ornamental clay tile roofs, as seen here, while others utilize tin roofs.

The following year, 1925, the houses once located at 3201 to 3233 St. Paul Street were built; all but those located at 3231 and 3233 St. Paul were razed in 2005 for the construction of the Village Loft condominium building. The same fate met the houses once located across the street from 3204 to 3222 St. Paul Street that year when they were razed in anticipation of the construction of another condominium building, the Olmsted. In 1927, the houses located between 303 and 347 East Twenty-ninth Street were built.

As a sign of the Great Depression, no development occurred for nearly nine years, until, in 1938, 3213 North Charles Street was built, now called the Abel Wolman House. Abel Wolman, who received a bachelor's of arts degree from Johns Hopkins in 1913 and a bachelor's of science degree two years later, was a highly regarded professor at Hopkins for fifty-two years. Born to Polish immigrants, he was known internationally for his expertise in water resources and public health. In 1919, Wolman and Linn Enslow, employees of the Maryland Department of Public Health, demonstrated a method for controlled chlorination of drinking water supplies that transformed water treatment, providing safe drinking water

throughout the world. The municipal building in Baltimore is named the Abel Wolman Building.

Wolman built the four-story house at 3213 North Charles Street in 1938 and lived there until his death in 1989, at the age of ninety-six. With the establishment of the state of Israel in 1945, he began service as chairman of the consulting committee on the development of the water system for the state of Israel in 1945, remaining in that position until his death. The house is considered by historians to be one of the most impressive works by noted architect Laurence Hall Fowler, who planned the War Memorial in downtown Baltimore. In June 1993, Hopkins trustee Harvey M. Meyerhoff bought Wolman's Charles Street house for a reported $191,000 and then donated it to the university. It first housed the Associated Jewish Community

The Charles Street Easter Parade became an institution in the neighborhood with large crowds in the 1920s, but by the late 1930s, it shifted to people showcasing their newly acquired automobiles. *P&J*

Federation of Baltimore so that Jewish students throughout Baltimore would have a place in which to socialize and worship together.

As with many urban areas of the United States, especially on the East Coast, Baltimore experienced a massive urban flight for white residents in the late 1960s and 1970s, as thousands left urban areas for suburban areas outside the city for better schools, increased recreational opportunities and a sense of safety that they did not feel could be attained in an urban environment. Baltimore's population in 1950 was just shy of 1 million residents; however, in 2006, it was roughly 631,000, a decrease of more than 300,000 residents. Charles Village felt the effects of this urban flight as rows and rows of houses were left vacant, and the neighborhood experienced a sharp decline in quality of life. However, the past few years have seen a renaissance in Charles Village as home buyers have been attracted to the architectural details found in the late Victorian homes. Programs such as Johns Hopkins University's "Live Near Your Work" initiative provide incentives for professors and Johns Hopkins staff to purchase homes in Charles Village. Also, Live Baltimore Home Center, an independent nonprofit organization founded in 1997 to promote the benefits of city living and provide home buying incentives, began a series of clever and effective marketing campaigns targeting Washington, D.C. residents at the start of the twenty-first century. This campaign drew many Washington, D.C. residents, fed up with living in cramped condominiums and apartments, to purchase homes in Charles Village, especially with its proximity to Penn Station, which allows residents to commute to Washington, D.C., via a local commuter MARC train. Additionally, many university students, especially those who rent in Charles Village during undergraduate or graduate school, purchase homes in the neighborhood following graduation.

Row house rehabilitation by local contractors in Charles Village has converted former multiunit apartment-style homes into single-family homes. Also, nonprofit organizations such as St. Ambrose Housing Aid, which creates equal housing opportunities for low- and moderate-income people, primarily in Baltimore City, have been able to purchase abandoned homes owned by Baltimore City and renovate them into single-family homes to offer for sale. St. Ambrose's strict adherence to historically accurate and sensitive architecture, exterior details and interior appointments allows Charles Village to maintain its cohesive look, while also converting former eyesores of the neighborhood into increased housing stock and opportunities for new homeowners to purchase single-family homes and express their pride of ownership.

APARTMENTS PROVIDE ADDITIONAL HOUSING

Although the massive building boom that occurred at the start of the twentieth century resulted in thousands of new row houses along St. Paul, Charles and Calvert Streets, as well as Maryland and Guilford Avenues, the influx of new residents from downtown also created the need for large apartment buildings. Apartment living was socially acceptable, even for wealthy Baltimoreans, so the ones built in Charles Village featured lavish appointments and well-known residents. The apartments built in the early 1900s were not the typical bachelor-pad apartments found today; instead, upper-middle-class residents yearned for upscale apartment living. Neighborhoods welcomed the construction of large apartment buildings to break the monotony of hundreds and hundreds of brick row houses, and builders and architects jumped at the chance to build them, as units would fetch as much as $3,500 a year in rent, a substantial amount for the time, considering that row houses could be built for about $5,000 at the dawn of the twentieth century.

Later, these apartment buildings would fill a different need—ample housing for students attending Johns Hopkins University and for empty nesters who wished to remain in Charles Village but no longer needed a large Victorian row house.

The first apartment building in Charles Village was the Peabody apartment building, built in 1906 in the 2900 block of North Calvert Street. It was designed by John R. Forsythe and built by Frances E. Yewell. The Homewood was the first structure built along the 3000 block of Charles Street at 3003 in

Changing social attitudes about apartment living and the need for more housing led to a construction spurt of several upscale apartment buildings in Charles Village, featuring lavish appointments and spacious accommodations.

1909. It was designed by architect Edward H. Glidden, facing north toward what was then open, rolling landscape. Glidden also financed the building project, attracting more than a dozen other prominent Baltimoreans into an investment syndicate that eventually expanded the apartment building in 1913 and again in 1915 to cover nearly the entire block.

Five years later saw the erection of two large apartment buildings in Charles Village. The apartment building at 3201 North Charles Street, coined Gladwyn Manor, was designed as a private home for Joseph W. Crook by architect Howard Sill and built in 1911. Sill, who became a member of the American Institute of Architects in 1916, was also chosen as the architect for the Baltimore Museum of Art, but due to his bad health, the museum's plans were instead carried out by John Russell Pope. Sill also designed the historic main house at Morven Farm, a Virginia Historic Landmark in central Virginia, and the historic Scaleby estate in Clarke County, Virginia, and was also a member of Sill, Buckler, and Fenhagen, the firm with which he designed the Federal Reserve Bank of Richmond.

Apartments Provide Additional Housing

The Homewood building, built in 1909, mimics a single-family home; however, the growth in popularity of apartment living led to the rapid expansion into a larger, multiunit apartment building.

He became best known, however, for his work with Colonial Revival houses and is said to be largely responsible for the high standards of design in the newly developed residential section north of Baltimore, including Roland Park. Gladwyn would later be significantly altered when it was converted into an apartment building.

Also, in 1911, the large complex known today as Hopkins Square on the southeast corner of North Charles and Thirty-first Streets was built in three stages. The corner portion was constructed first and opened as the Homewood Apartments. Large additions to the south were built in 1913 and 1915 by the same architect who designed the original portion, Edward H. Glidden. Glidden also designed Inglewood, a grand estate in Clifton Park, Ohio, for his cousin, varnish tycoon Francis H. Glidden; Archbishop Curley High School in Baltimore; as well as several apartment buildings in Baltimore, including Washington Place Apartments, which was a filming location for the feature film *My One and Only*, starring Renee Zellweger and Chris Noth. Hopkins Square now houses significant retail space on the lower

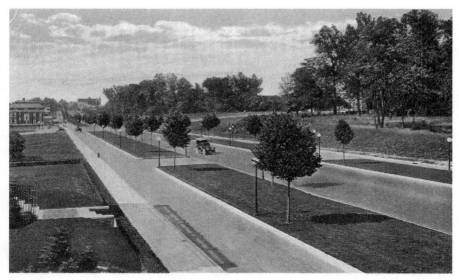

This vantage point of North Charles Street is from around Thirty-second Street looking south. Rising property values on Charles Street resulted in the majority of development occurring eastward, as shown by this 1910 postcard.

Calvert Court Apartments, built between 1914 and 1915 by Edward H. Glidden, cousin of Francis H. Glidden, the namesake of Glidden paint, features a spacious courtyard and classic design and is close to Johns Hopkins University.

level, including Ruby Tuesday, Kinko's, Tenpachi Hair Salon and Blimpie—all of which are geared toward and enjoyed by students at the adjacent Johns Hopkins University.

Apartment buildings continued to pop up in Charles Village, with the construction of a large apartment building at 101–115 West Twenty-ninth Street in 1914; however, it was left unfinished for several years due to the bankruptcy of the builder. The lower level today houses the beloved Charles Village Schnapp Shoppe, frequented by residents and upper-level students alike.

The Calvert Court apartment building in the 3000 block of North Calvert Street, also designed by architect Edward H. Glidden; the Woodrow apartments at 300 East Thirtieth Street, designed by architect Stanislaus Russell; and the Allston apartment building in the 3100 block of North Charles Street, designed by the architectural firm of Parker, Thomas, and Rice and costing $50,000 to construct, were all built in 1914.

The following year, two more apartment buildings were constructed: the Normandy apartments on the west side of the 2600 block of St. Paul Street, designed by architect Otto G. Simonson, and the Burford apartment building at 3209 North Charles Street by Parker, Thomas, and Rice, which also designed the St. Paul Court Apartments nine years later. Otto Simonson is a well-known Baltimore architect who was born in Dresden, Germany. At age twenty-one, he immigrated to Connecticut and was a supervising architect of the U.S. Treasury Department in the early 1880s. At the outbreak of the Spanish-American War, Simonson served as a senior captain in the army. After the war, he returned to the Treasury Department and was appointed superintendent of construction of public buildings. In 1904, Simonson was assigned the task of superintending the work on the new U.S. Custom House in Baltimore.

In 1935, jazz age writers F. Scott Fitzgerald and his wife Zelda rented a top-floor apartment in the Cambridge Arms building at 3339 North Charles Street, now known as a Hopkins's dorm coined Wolman Hall, which had had been built between 1919 and 1920 to the designs of architect Edward L. Palmer Jr. There, Fitzgerald worked on his autobiographical story *Afternoon of an Author*. Zelda had sought treatment in 1932 at the Phipps Psychiatric Clinic at Hopkins Hospital, and while she was a patient there, she penned the novel *Save Me the Waltz*. The Fitzgeralds moved to Charles Village from Bolton Hill, where he wrote the novel *Tender Is the Night*. He died in Hollywood in 1940.

Guilford Manor Apartments, built by Edward L. Palmer Jr., is hard to notice today, as it's dwarfed by a series of high-rise apartment buildings and hotels catering to Johns Hopkins students.

In 1920, the Briarley Hall Apartment building at 3203 North Charles Street was built, and in 1921, the Homestead Apartments and drugstore at 3101 St. Paul Street were built. Today, the basement level of this building is the site of Standard Cleaners and a location of one of Donna's restaurants, a local coffee shop and restaurant chain.

Also built in the early 1920s by architect Edward L. Palmer Jr., the Guilford Manor Apartments building at the intersection of Charles Street and University Parkway features one- and two-bedroom apartments and remains today. Palmer's architectural work can be found throughout Baltimore, and he is credited with much of the designs of the upscale northern Baltimore community of Cedarcroft.

The Hopkins Apartment building at 3100 St. Paul Street was designed by architect Frederic A. Fletcher and constructed between 1921 and 1922. It is known today as Wyman Towers, an apartment building popular with Johns Hopkins students. The apartment expansion continued in the 1920s in Charles Village with the construction of the Charles Apartment building in 1924, also designed by Frederic Fletcher. The Charles now serves as a dormitory for Johns Hopkins students, who can often be found in the popular dive bar on the basement level called PJ's Pub. Tragically, the Charles was

Apartments Provide Additional Housing

Many of the original apartment buildings constructed in the early to mid-1900s in Charles Village were either taken over by Johns Hopkins University for student housing or became accommodations catering to university visitors.

also the scene of a tragic murder of a Johns Hopkins senior in January 2005. The student, a rising Vietnamese researcher, was suffocated by the boyfriend of one of her sorority sisters in a botched burglary, as the intruder assumed no one would be home during winter break. The incident prompted the school to take further security measures.

The St. Paul Court Apartments at 3120 St. Paul Street—an off-campus apartment building for Johns Hopkins students—was also built in 1924. The building, set around a large courtyard, was designed by the famed architectural firm of Parker, Thomas, and Rice, which had designed Gilman Hall in 1913 and the Burford Apartment building on North Charles Street in 1915. The firm also designed the Alex Brown & Sons building in 1901, the Belvedere Hotel, the Baltimore & Ohio office building, the Maryland Casualty Company, the Savings Bank of Baltimore, the Metropolitan Savings Bank, the Gilman School and the campus plan and Academic Building for the Johns Hopkins University. In 1926, the Baltimorean Apartment building in the 2900 block of North Charles Street was built (later purchased in 1975 by the Johns Hopkins University for student apartments).

Four years later, in 1931, the Blackstone Apartment building at 3215 North Charles Street was built on the site of the 1909-built home of John B. Thomas that had been designed by Thomas C. Kennedy. In 1932, the Jefferson apartment building was built at 3200 St. Paul Street, but it was razed in 2005 to make way for the Olmsted condominium building. One of the latest apartment buildings in Charles Village is the Dell House Apartments on the southwest corner of North Charles and Twenty-ninth Streets, which were built between 1963 and 1964.

The past few years have seen the construction of new condominium and apartment buildings—the Village Lofts and the planned Olmsted building—near Johns Hopkins University, both of which cater to empty nesters who no longer yearn to take care of a large, single-family home and those who want to enjoy city living without having to deal with everyday maintenance.

THE INFLUENCE OF JOHNS HOPKINS UNIVERSITY AND GOUCHER COLLEGE

Charles Village, especially the northern section above Twenty-ninth Street, has been heavily influenced by one of the neighborhood's signature landmarks, Johns Hopkins University. The school, the largest private employer in Maryland, boasts several campuses in Baltimore and the state for its various schools; however, the main campus is the Homewood campus, which has called Charles Village home since the early 1900s. Many of the neighborhood's row houses have been converted into multiunit dwellings and rented out to Johns Hopkins students, and the area north of Thirty-first Street is dotted by various restaurants, bars and services catering to Johns Hopkins students.

Founded in 1876, Johns Hopkins University is named for Johns Hopkins, a wealthy merchant born in 1795 on a tobacco plantation in southern Maryland. Hopkins came to Baltimore at age seventeen to work for his uncle. Seven years later, he had his own mercantile house and later helped develop the Baltimore & Ohio Railroad, where he would later serve as director. Hopkins never married and decided to utilize his great wealth to form a university and hospital in Baltimore (some theorize that it was his friend George Peabody, who had founded the Peabody Institute, who helped Hopkins make his decision). In 1867, Hopkins named trustees to form Johns Hopkins University and Johns Hopkins Hospital. In 1873, Hopkins died, and his will stipulated that most of his $7 million estate be equally divided between the school and hospital. Hopkins did make some very specific stipulations in his will. The trustees were not allowed to spend any of his

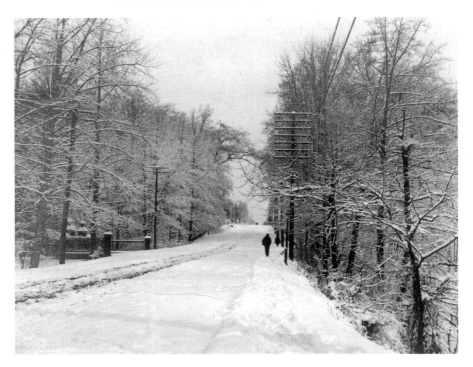

This 1897 photo of Charles Street at the gatehouse at Thirty-first Street looking northward shows the wooded, natural environment of what would become the Homewood campus of Johns Hopkins University within the next decade. *GS*

bequest to construct new buildings or pay current expenses; this would have to be done via fundraising. Instead, he stipulated that his donation be used partly for scholarships and that the Baltimore & Ohio Railroad stock, which was the lion's share of the bequest, be used wisely as the school grew. Hopkins selected the trustees, and they were actually not educators by trade. Hence, they relied on expert advice from the presidents of the day's prestigious universities, including Harvard University and Cornell University.

The trustees were in agreement that the first president of Johns Hopkins University would be Daniel C. Gilman, president of the University of California. Gilman traveled throughout Europe for ideas on the structure of the new university, and decided that—in addition to science and engineering—the school would also focus on the humanities. It was one of the first schools to implement faculty advisors to assist students. Gilman also placed an emphasis on graduate research and advanced study, a model that would have a lasting effect on future schools throughout the country, as well

as the esteemed Ivy League schools already in existence. Gilman would lead as president of Johns Hopkins University for twenty-five years.

Since its founding, Johns Hopkins University had been located in downtown Baltimore; however, school officials realized from the onset that the school would eventually outgrow its downtown campus and that a more suburban setting would be needed. In 1901, it was reported that over 150 acres of land on Charles Street had been donated by William Wyman for a new campus for the school. Wyman feared excessive residential development in Charles Village, so he decided to gift the land after being approached by his cousin, William Keyser, a Johns Hopkins University trustee. Keyser helped secure additional land surrounding the Federal-style Homewood House, a mansion built for the son of Charles Carroll, to complete the campus. In 1910, a $2 million campaign was launched to finance the construction of necessary buildings and to move the current campus. Construction began in 1911 for the first building, Gilman Hall, in honor of the school's first president, Daniel C. Gilman; it was dedicated in 1915. New buildings on campus would mimic the gorgeous architecture of Homewood House, creating a classic college campus.

In the late 1950s and early 1960s, the Homewood campus would undergo significant renovation and construction projects as the school battled the

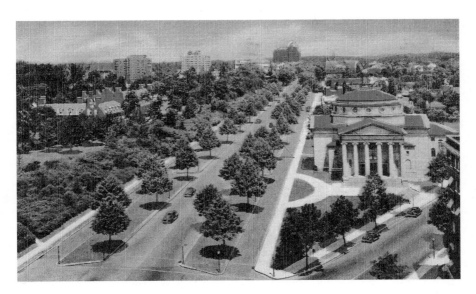

This postcard depicts Charles Street and Johns Hopkins University in the background. At this time, Charles Street was a two-way boulevard and featured gorgeous landscaping by the famed Olmsted Brothers firm from Boston.

physical constraints of its current campus. In addition to expansions to Rowland Hall and Mergenthaler Hall, four new buildings were constructed—Dunning Hall, for research work done by the Department of Chemistry; Macaulay Hall, for the Department of Earth and Planetary Sciences; Barton Hall, for research in radiation and electrical engineering; and the Milton S. Eisenhower Library, which provided much-needed space for collections and new computer equipment, as Gilman Hall had reached its capacity. Later additions included a new athletic center for students and members of the university community.

Additionally, Johns Hopkins University has added a number of buildings that also benefit Charles Village residents, including Shriver Hall, built in 1954 and home to a very popular annual concert series featuring chamber music by well-known artists. One of the peculiar components of Shriver Hall is that benefactor Alfred Jenkins Shriver stipulated that Shriver Hall must contain a mural of Baltimore's ten most beautiful women of his day. Each spring, the Hopkins Spring Fair is held, drawing neighborhood residents to enjoy music and entertainment. Another rite of passage in the spring is the beginning of lacrosse season. Due to the sport's small community feel, Charles Village residents head to Homewood Field to cheer on the Blue Jays, a team with national prominence—Johns Hopkins has nine lacrosse national championships. Homewood Field is also home to the National Lacrosse Hall of Fame.

Students at the Women's College of Baltimore, later renamed Goucher College in 1910, take part in a chemistry lab. The suburban campus called Charles Village home from 1885 to 1954. *GCL*

Bennett Hall was the home to physical education for the Women's College of Baltimore, an early emphasis at the school. Students utilized the building's gymnasium, pool and bowling alley. *GCL*

Johns Hopkins's leafy, serene campus also provides recreational opportunities, as well as plenty of space for reading and relaxation. The 2000 campus master plan also added more green and open spaces, and the creation of bike lanes on campus in 2008 offered more recreational opportunities for Charles Village residents.

As is the case with many colleges that are situated within residential areas, there is a certain "town and gown" friction in Charles Village. Rowdy fraternity parties and historic row houses being split into multiunit dwellings can be frustrating for neighbors, as are those renters who do not keep up with their yards or exterior of their homes. However, the blending of Johns Hopkins with Charles Village does pose many advantages for the neighborhood. The constant ebb and flow of students creates a strong rental market for those homeowners looking to rent out a portion or all of their homes. Additionally, having students reside in Charles Village creates a youthful energy, and the university provides its own security staff that patrols the neighborhood, which helps with safety concerns. The school also promotes the "Live Near Your Work" grant to encourage its employees to take advantage of grants available to purchase a home in Charles Village.

In addition to the school's main Homewood campus in Charles Village, the school has several other campuses in Baltimore, suburban Baltimore

and Washington, D.C., including the famed School of Medicine and Johns Hopkins Hospital in East Baltimore, consistently ranked as the number one hospital in the United States, and the School of Public Health, also in East Baltimore. The school's groundbreaking research and advances in public health resonate around the globe.

Although no longer situated in Charles Village, another college once called the neighborhood home—Goucher College, which was situated in lower Charles Village from 1885 to 1954. The genesis of Goucher College is tied to another Charles Village landmark, Lovely Lane United Methodist Church, the first Methodist church in the United States. In 1885, while celebrating the centennial of the church, the pastor, Dr. John Goucher, decided that a women's college should be situated in his community. Originally named the Women's College of Baltimore, the college opened in 1885 with forty-eight students, was renamed Goucher College in 1910 and became coed in 1986. Dr. Goucher's dream to start Goucher College was aided by his wife, Mary, who was born into a wealthy family in Pikesville, Maryland.

Dr. Goucher was born in Waynesboro, Pennsylvania, in 1845 and was raised in Pittsburgh. He achieved great academic success, and in addition to the ministry, he was a philanthropist, missionary and avid traveler. In 1909, the steamship *Florida* collided with the *Republic* and sank. Dr. Goucher, who was aboard the ship, heroically used his electric torch to lead passengers to deck to be rescued.

Dr. Goucher and his wife resided at 2313 St. Paul Street, a grand home built in 1892 by the famed architectural firm McKim, Mead and White of New York City (see Chapter Two). Stanford White designed the home, which was built at an astounding cost of more than $100,000 at a time when other area homes were built for around $5,000. In 1906, as the Gouchers embarked on an around-the-world trip, Dr. Goucher deeded the home—called the Goucher House today—to the college; however, the trustees insisted that he retain ownership until his death. Dr. Goucher died in 1922, and the school took ownership of the house. It was used as a dormitory from 1922 to 1950. Twenty-one students resided there each year. Today, it is the corporate headquarters of Alpha Phi Alpha Fraternity, the first intercollegiate Greek-letter fraternity established for African Americans.

McKim, Mead and White also designed Goucher College's Bennett Hall of Physical Culture at 2300 St. Paul Street. On June 4, 1888, the Port Deposit granite cornerstone was laid, and the building's $25,000 cost was donated by Benjamin Franklin Bennett in honor of his late wife,

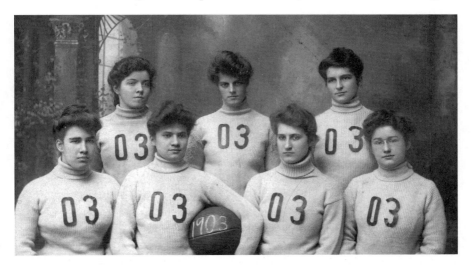

The 1903 Women's College of Baltimore basketball team showcases hairstyles definitely not found on today's collegiate basketball players, a testament to the Victorian attitudes of the day. *GCL*

Eleanor. The athletic building, known to be one of the finest women's gymnasiums in the world at the time, featured a gymnasium, pool and bowling alley. The physical education staff was all imported from Sweden, and they all utilized Zander machines, muscle-resistance chairs developed by Gustav Zander, a Swedish physician. Goucher College sold Bennett Hall and Bennett Hall Annex to the State of Maryland in 1945 for $75,000. The building was renovated (including the removal of the tennis courts in front of the hall) and housed the Maryland State Health Department from 1950 to 1976. Today, it serves as the headquarters of the Maryland Geological Survey.

The school's original goal was to educate women of high character and for the curriculum to challenge the one found at nearby Johns Hopkins University, with an additional emphasis on physical fitness, as evidenced by the construction of Bennett Hall. By 1908, the school offered four courses of study—classical, modern languages, natural science and mathematics, with additional special courses in art, music and education.

However, the school believed it never had a true campus in Baltimore, as buildings were scattered throughout Charles Village, so beginning in the 1920s, plans were made to relocate to Towson in Baltimore County. President William Guth purchased 421 acres from an estate near Towson, but financial difficulties during the Great Depression delayed moving the

The Alumnae Lodge, seen here in 1917 with three coeds relaxing, was located at the corner of East Twenty-fourth and Charles Streets on Goucher College's campus. *GCL*

campus. Goucher opened its first residence hall in Towson in 1942, the same year that commencement was held on the new campus. Since classes were still being held in Charles Village, the school utilized four station wagons to transport some students and subsidized trolley fares for students to commute

back and forth, reducing the fare to twenty-nine cents round trip. The school completed its move to Towson in 1954, and the Old Goucher College Historic District was officially placed on the National Register of Historic Places in 1978.

Although the school is no longer in Charles Village, it continues to have an impact in the neighborhood, thanks to the Old Goucher Neighborhood Collaborative, located at 2526 North Charles Street. Led by the efforts of Robert Koulish, PhD, the France-Merrick Professor of Service Learning at Goucher College, the school and its students have partnered with area businesses and schools, including Dallas Nicholas Elementary School, located in Old Goucher, to help in revitalization efforts and improve local schools. Additionally, Dr. Koulish led efforts to reintegrate the school with the twenty-one original buildings that still stand in Old Goucher, including the eighteen that are listed on the National Register of Historic Places.

Today, the liberal arts and sciences college has an enrollment of 1,350 undergraduates and 1,000 graduate students, and its campus comprises 287 acres in Towson. Goucher College offers degrees in thirty-one majors; master's degrees in education, creative nonfiction, arts administration and historic preservation; and a unique one-year post-baccalaureate premedical program, preparing graduates with little or no science background for entrance into medical school.

CITY WITHIN A CITY

While the historic and gorgeous residential architecture has made Charles Village one of Baltimore's most famed neighborhoods, for residents of Charles Village, the presence of religious, commercial, cultural and educational institutions is equally as notable, allowing residents to reside in a "city within a city." Residents of Charles Village are fortunate to live in a neighborhood where access to an automobile is not necessary, as life's everyday necessities can be accessed via a short walk. In addition to the convenience factor, these institutions have also played a key role in Charles Village's rich history.

RELIGIOUS INSTITUTIONS

Like many Baltimore neighborhoods, Charles Village has been heavily influenced by the many religious institutions that have called the neighborhood home for many years. Many different religions and denominations have a presence in Charles Village, reflecting the neighborhood's diverse makeup. The students from all over the world who come to Johns Hopkins University and make Charles Village their temporary or permanent home have also helped shape the neighborhood, as Buddhism, Islam and other religions have a presence.

On the southern edge of Charles Village is Lovely Lane Methodist Church, which began in 1784 at the church's original home on Redwood Street in

Father John Wade, seen here at front center with the 1921 graduating class of Saints Philip & James School, was instrumental in expanding the church's presence in the neighborhood. *P&J*

downtown Baltimore. It was there, at the Lovely Lane Meeting House, that the Methodist Episcopal Church of the United States was first formed at the Christmas Conference, and Reverend Francis Asbury was ordained as first bishop. The congregation later built a new church between 1884 and 1887 at 2200 St. Paul Street, continuing the church's proud heritage as the "Mother Church of American Methodism." Designed by Stanford White, the church was built of granite ashlar stone in the Romanesque style, with the most recognizable feature being the square bell tower.

Just five blocks north of Lovely Lane is St. John's of Baltimore City United Methodist Church, at 2640 St. Paul Street, a church that has undergone many name changes over the years and whose congregation began on Liberty Street in downtown Baltimore between 1815 and 1820. The property at Twenty-seventh and St. Paul Streets was purchased in 1899 for $12,000, and construction began on a new building in 1900 at a cost of $38,600 by architect B.F. Owens. On December 16, 1981, a five-alarm fire ripped through St. John's, seriously damaging the building; however, due to congregation and community support—as well as an insurance settlement—a new roof and a smaller worship space was reconstructed in the rear of the church building.

St. John's of Baltimore City United Methodist Church at 2640 St. Paul Street, which experienced a devastating fire in 1981, has been a longtime pioneer in assisting those less fortunate in the community.

Like many urban churches, St. John's membership has changed with the demographics of Charles Village and the surrounding neighborhoods of Remington and Harwood. The church has a long history of helping those less fortunate around the globe, as well as here in Baltimore, and in 1987, St. John's served as a "sanctuary church" to house undocumented persons from El Salvador. St. John's also has a long history of reaching out to the gay, lesbian, bisexual and transgender community, and in 1985, it became the thirteenth reconciling congregation in the United Methodist Church, openly accepting lesbian and gay people in the congregation. Members of the church have since marched in gay pride parades in Baltimore and Washington, D.C., and in 2005, it helped form the Baltimore-Washington Area Reconciling United Methodists (BWARM) to network and support those congregations that support full inclusion of LGBT persons in the church. St. John's, which by 2002 had a congregation of only about ten dedicated members, embraced its pastor, Reverend Ann Gordon, who in 2006 began hormone and medical treatment to change her sex to become Reverend Drew Phoenix. In October 2007, the Judicial Council of the United Methodist Church announced that Reverend Phoenix would remain at the church, despite some objections by conservatives within the organization, and church membership has grown from ten to fifty. In 2007, the 2640 Cooperative was formed in conjunction with Red Emma's Bookstore Coffeehouse, allowing the church to lease space to organizations and individuals to help raise funds and increase community involvement. Yoga, tai chi, book sales, holiday fairs and radical political discussions are just some of the happenings held at the church today.

The Franciscan Sisters of Baltimore, who began their ministry in 1891, provide emergency services such as feeding the hungry and caring for orphans in the Charles Village community, as well as other areas of Baltimore. For years, the Sisters have called 2212 Maryland Avenue home, but by the mid-1960s, the building was nearly empty. So, with a generous donation by a couple from Philadelphia, the Franciscan Center opened on September 10, 1968. In 1980, the center acquired the adjoining row house, and it is now able to serve hot meals and expand its services to include a new Emergency Assistance Program and AIDS Outreach program. With the closing of the St. Francis School at 2226 Maryland Avenue, the center now resides in a modern, state-of-the-art space.

One of Charles Village's oldest churches has called the neighborhood home since 1897, albeit in two different locations. On September 5, 1897, a granite stone from Port Deposit, Maryland, was blessed to become the

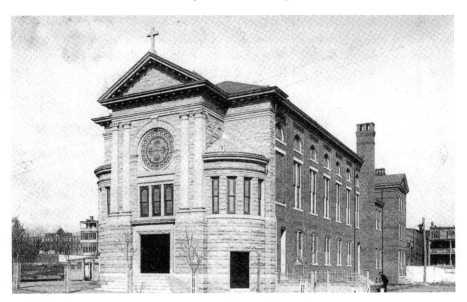

Constructed in 1897–98, the original home of Saints Philip & James Catholic Church housed the sanctuary on the second floor, while the ground floor contained a small parish school and the priests' quarters. *P&J*

cornerstone of Saints Philip & James Roman Catholic Church in the 2700 block of North Charles Street. The church was named in honor of James Cardinal Gibbons and was designed by architect John Stack Jr. and built by Cornelius Sheehan, who also built Charles Village's Margaret Brent Elementary School. The church was completed in 1898 and was opened to residents on Easter Sunday that year, becoming the first church in the Peabody Heights section of Charles Village. With the church's increase in parishioners came the need for the church to find a larger home. After departure, the granite building was converted into Church Apartments in 1943 and later served as a Red Cross blood facility. Today, it serves as the home of the Johns Hopkins University Press, the nation's oldest university press.

Due to the population growth in Charles Village and surrounding neighborhoods, the church knew it was in need of a larger home. In 1920, the church purchased the 2800 block of North Charles Street, which included the gorgeous Ulman mansion, for an astonishing $112,000. The home was rented for a few years before being razed to make way for Saints Philip & James's new cathedral. A prominent local architect, Theodore Pietsch, was

This Easter Parade shot shows the new rectory under construction in September 1929. Saints Philip & James razed the historic Ulman mansion to make way for the new building. *P&J*

hired to design the new cathedral. He also designed the old Eastern High School on North Avenue and the Recreation Pier in Fell's Point.

The impressive building at 2801 North Charles Street, with its signature dome, was dedicated on June 15, 1930, and the altars and statues were moved from the original 1897 building to the new one. The church's convenient location was also beneficial each Easter, as one of Baltimore's biggest annual events in the 1920s and 1930s was the Easter Parade held on North Charles Street, with attendance of almost seventy-five thousand people.

Three blocks north of Saints Philip & James is another testament to Charles Village's religious diversity. The Homewood Friends Meeting House at 3107 North Charles Street was built in 1921 and is used by the Religious Society of Friends—the Quakers. Baltimore has a long history of Quakers, as the famed Pratt family, who established both the Enoch Pratt Library and the Shepard Pratt Mental Hospital, were Quakers.

Closer to Johns Hopkins University lie the University Baptist Church, at 3501 North Charles Street, which was founded in 1917 to serve both the university and northern Baltimore City residents, and the Bunting Meyerhoff

Interfaith and Community Service Center, at 3509 North Charles Street. Formerly known as the Alpheus W. Wilson Memorial Methodist Church and built in 1919, the center was converted so that all faiths, including Christian, Jewish, Buddhist, Muslim and Hindu, could worship there. Steps taken included painting the red door burgundy and installing frosted-glass shutters to cover the stained-glass windows of Christ for non-Christian worships.

Some of the other religious institutions in Charles Village include the Cathedral of the Incarnation, 4 East University Parkway; Mount Carmel Baptist Church, 212 East Twenty-fifth Street; Vikatadamshtri Buddhist Center, 2937 North Charles Street; and the Baltimore Shambhala Meditation Center, 3501 St. Paul Street, where classes in meditation and Buddhist practice are held.

COMMERCIAL TRANSITION

For many years, the only commercial institutions in Charles Village were pharmacies; however, now the neighborhood is home to ample restaurants, bars, clothing stores and grocery stores, as well as everyday convenient services, such as dry cleaners, hair salons, card shops, florists, liquor stores and small food markets. In fact, the Hair Unlimited hair salon at the St. Paul Court building in the 3100 block of St. Paul Street has been a working beauty salon for eighty years. Owned by Saba Hisma for fifty years and then Ellen Gifford since 1978, the hair salon has been popular with residents and Johns Hopkins University students for years.

One of the earliest major fixtures in the neighborhood was Union Memorial Hospital, which opened in 1854 and is still an important healthcare institution for Charles Village residents today. Started by seven women to aid the sick and the poor and originally called the Union Protestant Infirmary, Union Memorial has evolved from a 20-bed hospital to a 279-bed hospital with more than two thousand employees. The hospital is also notable for its historic Japanese cherry tree donated by none other than Al Capone, who donated two trees in 1940 (one was chopped down in 1955 during a hospital expansion). Capone donated the trees after he was treated for syphilis at Union Memorial Hospital after being refused treatment at Johns Hopkins. According to records, Capone brought along a massage therapist, manicurists, bodyguards and chefs for his stay.

Definitely one of the most striking and beautiful commercial buildings in Charles Village is the Copy Cat Store at Twenty-fifth and North Charles

Union Memorial Hospital has been a neighborhood fixture in Charles Village since 1854. The hospital gained notoriety in 1940 when patient Al Capone donated two Japanese cherry trees after being treated at the hospital for syphilis.

Streets. Originally built by one of the first women developers in Baltimore circa 1890s, the Copy Cat Store features a Moorish-style design, with its large, horseshoe-shaped window, bronze display windows, recessed upper-story porch and a high, round turret capped by a crescent moon. In 1892, Robert T. Petzold opened the North Baltimore branch of the Kenyon Chemical Company in the Twenty-fifth Street section of the building, while his family lived in the Charles Street portion. It remained a drugstore for many years through many owners, including the Thomas & Thompson Store in the 1930s, which was popular with Old Goucher residents. After suffering years of neglect, the Baltimore firm of David Gleason & Associates was hired to restore the façade of the building and reconstruct the two-story rear porch; the project garnered a Baltimore Heritage Block-by-Block Award. The Copy Cat Store occupied the space for many years before moving south two blocks in late 2008.

Another commercial institution that played an important part in Baltimore's history is Baltimore Storage at 2600 North Charles Street, which opened in 1923 and is a local agent for Mayflower Transit Co. On March 29, 1984, however, the company faced enormous local scrutiny—albeit unwarranted —when the local newspaper published the iconic and heartbreaking photo of

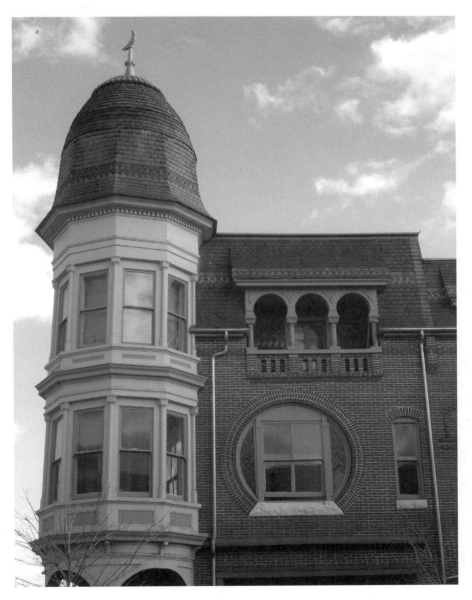

The striking Copy Cat Store at Twenty-fifth and North Charles Streets was once the home of the Kenyon Chemical Company and the Thomas & Thompson Store. It was built in the 1890s.

the beloved Baltimore Colts football team sneaking out of town in the middle of a snowy night to relocate to Indianapolis…in Mayflower moving trucks. Accusations of treason were hailed at the Charles Village–based moving company; however, Baltimore Storage knew nothing of the top-secret move, as the Colts had deliberately hired the Alexandria, Virginia Mayflower branch to prevent word getting out of the team's sneaky move. For years, Baltimore Storage had to plead its innocence, and when Baltimore finally got a new football team in 1996, the company ran a large ad in the inaugural season program to remind Baltimore football fans of its innocence.

One of the two grocery stores in Charles Village, and one of the most ardent supporters of the neighborhood, is Eddie's Market/Charles Village, a small, local supermarket that is famous for its deli sandwiches, which all have creative names, many of which pay homage to the neighborhood. It is also noted for its enthusiastic support of Johns Hopkins lacrosse and neighborhood initiatives. Eddie's Market/Charles Village was one of the earliest franchises of the well-known Eddie's Supermarket chain, which was begun in the 1940s by Eddie Levy and once claimed twenty-six locations in Baltimore. Levy's brother-in-law, Herman Kabik, was the original owner of the Charles Village location and is the grandfather of the current owner, Jerry Gordon. In 1962, St. Paul Supermarkets, Inc., made up of a group of businessmen that included Eddie Gordon, Jerry Gordon's father, bought the Charles Village store. Jerry, who began as a grocery bagger when he was fourteen, has run the supermarket since 1980. Eddie's is also a popular local hangout at breakfast with its outdoor tables and serves Baltimore's famous Zeke's Coffee.

Charles Village also has a Safeway grocery store in the 2400 block of North Charles Street, which was once the home of an Art Deco Chesapeake Cadillac Company showroom designed by Howard F. Baldwin. Chesapeake Cadillac operated there from 1930 until the mid-1990s, when the owner relocated to Cockeysville and sold the building to Safeway. Although the building was torn down to make way for the grocery store, the iconic Cadillac eagles remain on three corners of the Safeway building. In the 1970s, Charles Village also had an A&P grocery store in the 3100 block of St. Paul Street, where Bert's restaurant stands today.

Residents also take advantage of the Thirty-second Street Farmers' Market every Saturday, the city's only year-round farmers' market. Farmers from around the area sell everything from fresh vegetables and fruits to flowers, cheese, meats, milk and coffee. The market is also a popular social gathering area for neighbors.

City Within a City

The west side of the 2700 block of North Charles Street has traditionally been the site of healthcare institutions. The original mansion that stood there became the Bredler and Sellman Sanitarium. Later, in the early years of the twentieth century, the building housed the Maryland Academy of Sciences, Maryland's oldest scientific institution. The Academy of Sciences was a scientific society where members would meet to discuss all fields of science, including zoology, botany, astronomy and other natural sciences. Some of the prominent members were Rembrandt and notable Baltimore families, including Howard, Gilmor, Ellicott, Charles Carroll and J.H.B. Latrobe, son of the famous architect. The building later housed the Doctors Hospital, North Charles General Hospital, Homewood Hospital, Mariner Health Systems Nursing Home and is now the home of the Future Care Nursing Home.

The heart of the commercial area in Charles Village is undoubtedly the east side of the 3100 block of St. Paul Street, which was originally constructed as private homes around 1923. The commercial strip is now home to Eddie's Market, the Charles Village Pub, Bert's restaurant, Gordon's Florist and Sam's Bagels, among others.

At the corner of Thirty-first and St. Paul Streets is the neighborhood's longtime favorite restaurant, Donna's, located on the first floor of the original Homestead Apartments and drugstore, built in 1921. Charles Village residents recall that the restaurant used to be the location of the Hopkins Store, called colloquially "The Dink" by neighbors. Owned by Mr. and Mrs. Cohen, the Hopkins Store was famous for carrying an odd assortment of goods, and neighbors recall that you could find whatever you needed, no matter how arcane—eyelash curlers, Coca-Cola syrup, staplers, flea powder, pacifiers, games, puzzles and cigarette papers. A longtime Charles Village resident recalls that his daughter was instructed to clean her flute with cigarette papers, and he did not realize that selling cigarette papers to minors was illegal, so he sent her to the Hopkins Store to buy some; she was refused. Neighbors also recall the handy Sam's Belly neighborhood cooperative food store on Thirty-first Street, a great place to get fresh produce and grains, and you could grind your own peanut butter. Sam's Belly was owned by the late Gussie Tweedy, a pioneering African American businesswoman and peace activist.

Due to the large number of college students in the neighborhood, Charles Village is also home to a significant number of liquor and wine shops, as well as drinking establishments, including PJ's Pub at 3333 North Charles Street. Named for owners Paul and Jerry, PJ's Pub is located on the basement level of the Charles Apartment Building, built in 1924 to the designs of architect

Frederic Fletcher. A new wine and spirits shop, Lady G's, opened in 2008 and now provides residents with a more upscale shop.

Recent commercial development in Charles Village has been dominated by the massive projects in the northern part of the neighborhood near Johns Hopkins University. Local developers Struever Bros. Eccles & Rouse built Charles Commons in 2007, comprising a large Barnes & Noble Bookstore, which also doubles as a student bookstore for Johns Hopkins, as well as two student housing buildings. The bottom floor of another Struever project, the Village Lofts residential building, houses several restaurants, coffee shops and clothing stores. The Olmsted building, also by Struever, is slated to include retail space when it's completed.

Educational and Cultural Institutions

Charles Village has had many primary educational institutions, one of which would serve as a national model for future day and boarding schools as the first day country school in the nation. The idea for the school was formed by Anne Galbraith Carey, who wanted her son to attend a school in a country setting rather than a city public school; however, she did not want to send him away to a boarding school in New England. She enlisted the help of prominent Baltimoreans, including famed educator Daniel C. Gilman, the first president of Johns Hopkins University.

In 1897, the Country School for Boys was founded. The school catered primarily to wealthy families in Mount Vernon and Bolton Hill, as it provided an exceptional education for boys in what was then a country setting. The boys would spend their entire day at the school and be fed a substantial dinner in the middle of the day, and study hours at the school negated the need for studying at home for the younger boys. A limited number of boys were also allowed to be boarded at the school.

The school was located at the historic Homewood Estate, and twelve acres of land were leased by the school. As the school's register stated, "Space is provided for base-ball and foot-ball grounds, lawn tennis courts, a practice cricket crease, and, for those boys who cannot take part in such vigorous out-door games, garden plots which they may cultivate as they please." The location was not only idyllic but also convenient, as students could ride the electric car from home to the stop at Thirty-first and St. Paul Streets and then walk along the boardwalk to campus. Boys also had to have "at the School a pair of heavy shoes and an extra pair of stockings, a jersey, a sweater, a pair

Founded in 1897, the Country School for Boys, later named the Gilman School, served as a national model for future day and boarding schools as the first day country school in the nation. *GS*

of canvas knickerbockers, a gymnasium shirt, a pair of 'Turner' trousers, a comb and brush, and a half dozen handkerchiefs." Tuition was steep for the time—$150 a year for the lower school; $200 a year for the middle school; and $250 a year for the upper school. Parents also paid $1.75 a week for dinners, and for those boarding students, an additional $500 a year was assessed.

In 1910, the school moved to its current sixty-eight-acre campus in Roland Park and changed its name to the Gilman Country School for Boys. In 1951, the school was renamed Gilman School. The current upper-school building, Carey Hall, is named for Anne Galbraith Carey, and its architecture mimics Homewood House, the school's original home.

Margaret Brent Elementary School, 100 East Twenty-sixth Street, was built between 1896 and 1897 as an all girls' school, and a contemporary building and playground later replaced the original school. The school was named for Margaret Brent, who immigrated to Maryland in 1638. Brent

Athletics were a major part of the curriculum at the Country School for Boys, as the school's country setting allowed for increased recreational and athletic opportunities not available in downtown Baltimore. *GS*

never married and was an active businesswoman who imported and sold servants and lent capital to incoming settlers. She is best known for a 1648 act in which she asked the governor and assembly to give her two votes, one as a landowner and one as Lord Baltimore's attorney; this was a bold step for a woman of her day. A memorial to her is located in St. Mary's City, Maryland. Today, the school is a great resource for Charles Village families, and the playground serves all. In an effort to attract new teachers to the area, two buildings in the neighborhood have been slated to be converted into teachers' housing, one at St. Paul and Twenty-fifth Streets by the Safeway and the other in the long-vacant H.F. Miller & Son Tin Box and Can Manufacturing plant at 2601 North Howard Street, a thirty-thousand-square-foot building built in the late 1800s that once served as the U.S. Census Bureau.

In 1907, St. Joseph School of Industry, a manual training school for women, moved from its location at Carey and Lexington Streets, where it had been since 1865, to a large stone and brick building designed by architects Tormey and Leach at 2800 North Charles Street. In 1926, the school was reinvented as a girls' high school called Seton High School, focusing on academic and business programs. In 1917, Saints Philip & James Church added a parochial school at 2701 Maryland Avenue, called the Peabody Heights Academy. The elementary school was housed in a limestone building built between 1916

Saints Philip & James once afforded Charles Village residents a local option for a coeducational parochial education. The schoolhouse now serves as an apartment building. *P&J*

and 1917 and designed by Hugh Kavanagh. In 1988, Seton High School merged with Archbishop Keough High School in southwest Baltimore and relocated there, and the following year saw the closure of Peabody Heights Academy due to declining enrollment.

Further adding to Charles Village's education endeavors is the Village Learning Place at 2521 St. Paul Street, which was once a branch of the Enoch Pratt Free Library system, the collection of public libraries created by Enoch Pratt in the late nineteenth century. The Peabody Heights branch, designed by Charles L. Carson, opened November 14, 1896, with 6,500 books. Due to its proximity to Goucher College, the branch was especially popular with college students. In 1906, the lot behind the library was purchased and a garden was planted, which still thrives today. In 1920, electricity replaced gaslights, and in the 1940s, library officials considered closing the Peabody Heights branch and building a larger branch at North

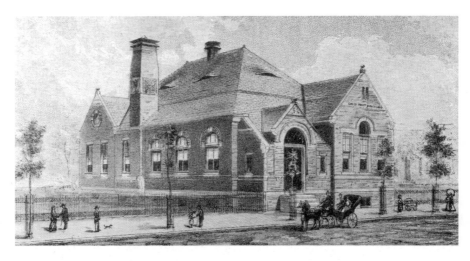

Once a branch of the Enoch Pratt Free Library System, the Learning Place on St. Paul Street today offers continuing education classes, a library and after-school programs for Baltimore City schoolchildren. *EPFL*

Avenue and Calvert Street. Luckily for neighborhood residents, the existing branch was renovated in 1952.

In 1997, the Peabody Heights branch closed; however, a group of citizens and business owners organized to restore the historic building and reopen it as a community learning place. Since then, the Village Learning Place has been offering educational services for young people and senior citizens and has a collection of over fifteen thousand books available for checkout. Programs include everything from gardening symposiums to wine appreciation to unique, safe after-school programs for Baltimore City students.

Since 1929, the signature cultural institution in Charles Village has been the Baltimore Museum of Art, located on Art Museum Drive off Charles Street. The museum was founded in 1914 and had a temporary location in the Garrett-Jacobs Mansion in Mount Vernon. In 1924, a $1 million loan was granted to construct a permanent home, and prominent architect John Russell Pope was hired to design the building. Pope was a well-known architect of such Washington, D.C. landmarks as the National Gallery of Art, Scottish Rite Temple, the Jefferson Memorial and the National Archives, and he also designed the Garrett-Jacobs Mansion's expansion in 1905.

On April 18, 1929, the Baltimore Museum of Art opened, and in 1950, the museum gained international acclaim when the famed Cone sisters

The beautiful Sculpture Hall at the Baltimore Museum of Art is seen circa 1929, the year the famed museum opened in its new location on North Charles Street in Charles Village. *BMA*

of Baltimore—Claribel and Etta—donated works by Matisse, Picasso, Cézanne and Gauguin. The sisters were born in Tennessee to German-Jewish immigrants who started a grocery store and saw it flourish into a lucrative export business. The family then moved to Baltimore, while the two

Baltimore mayor Howard Wilkinson Jackson breaks ground in 1927 for the Baltimore Museum of Art's new building. Note the rural nature of Wyman Park and the surrounding area of Charles Village at the time. *BMA*

elder brothers started a very successful textile business in North Carolina. Claribel became a pathologist, and the two sisters were immersed in the aristocratic social scene in Baltimore. They traveled the world, often visiting Gertrude Stein—who also lived in Baltimore—in Paris. In the biography *Dr. Claribel & Miss Etta*, by Brenda Richardson, it is speculated that Etta and Stein were lovers. In 1905, Etta bought her first etching at Picasso's Paris studio, and over the next four decades, the two sisters would amass over 3,000 works of art, including 500 works by Matisse, considered the largest and most significant Matisse collection in the world; 114 works by Picasso; as well as works by Cézanne and Vincent van Gogh. Several museums vied for the Cone Collection, but Etta insisted that it go to the Baltimore Museum of Art upon her death in 1949.

In 1980, a Sculpture Garden was added, and the museum now has ninety thousand works of art. The popular restaurant Gertrude's by celebrity chef John Shields in the BMA features Chesapeake cuisine and is a local favorite of many Charles Village residents.

Etta and Claribel Cone, seen here with friend Gertrude Stein at right vacationing in Florence, Italy, in 1903, would amass over three thousand works of art and donate their collection to the Baltimore Museum of Art. *BMA*

Adjacent to the Baltimore Museum of Art is a recreational treasure for Charles Village residents, as well as Johns Hopkins University students. Wyman Park Dell, a sixteen-acre public park, lies south of the BMA and Johns Hopkins University and offers a quiet respite from city life. Conceived between 1911 and 1914 by the famed Olmsted brothers, who also designed Central Park in New York City, Wyman Park Dell is known for its steep steps from North Charles Street that lead down to the park. In 1905, when Johns Hopkins University was planning on building a new campus nearby, Wyman Park was described by the *Baltimore News* as a very rough and heavily wooded territory famous for chestnut expeditions. In 1913, in an effort to promote Wyman Park, the Peabody Heights Improvement Association set aside a Sunday to encourage residents to discover the benefits of Wyman Park as volunteers outlined points of interest. In 1983, a group of Charles Village and Remington neighbors established the Friends of Wyman Park Dell to help revive the park and increase awareness of Wyman Park Dell's historical significance. Today,

Thanks to the foresight of William Wyman and his generous land donation, Wyman Park's sixteen acres of land afford Charles Village residents and Johns Hopkins University students a respite from everyday nuisances.

Wyman Park Dell is popular with dog owners and college students, who utilize the many benches and shady areas during the warmer months, and is the site of the annual Charles Village Festival in June and the Winter Solstice Celebration in December.

Wyman Park is also the site of a controversial annual event. Each January, descendants of Confederate soldiers gather in Wyman Park to march, sing and lay wreaths at the monument to Robert E. Lee and Stonewall Jackson. The seven-ton, fourteen-foot-high monument of Jackson and Lee was dedicated in 1948 and shows the two generals at their last meeting, in 1863. The NAACAP opposes the gathering, especially since the gathering coincides with the birthdays of Lee and Jackson, which annually occurs close to the birthday of Martin Luther King Jr. and, in 2009, occurred shortly before the inauguration of the United States' first African American president, Barack Obama.

Adjacent to Wyman Park Dell stands another monument, albeit for the opposing side of the Civil War. At the corner of Twenty-ninth and North Charles Streets is the Union Soldiers and Sailors Monument. The large bronze sculpture features an exedra and a built-in bench and the Latin words

The large bronze statue called the Union Soldiers and Sailors Monument, dedicated in 1909 and adjacent to Wyman Park, pays tribute to Civil War soldiers yet is overshadowed today by mature trees.

meaning "Thou hast crowned us with the shield of Thy good will," words also seen on the state seal of Maryland. The Maryland General Assembly authorized the building of the statue in 1906. It was dedicated three years later, on November 6, 1909.

New York sculptor Adolph Alexander Weinman (1870–1952) created the large bronze sculpture, which was cast in 1909 by the Roman Bronze Works in New York. A.A. Weinman, who was born in Germany in 1870 and came to the United States at the age of ten, studied under Augustus Saint-Gaudens, the preeminent sculptor-medalist at the time. Weinman's early work was highlighted by a sculpture featured at the St. Louis World's Fair, a statue at the U.S. Supreme Court building and a statue of Abraham Lincoln for the Lincoln Monument in Frankfort, Kentucky. He is best known as the designer of the U.S. "Mercury" dime and the "Walking Liberty" half dollar for the U.S. Treasury Department.

It's no surprise that Charles Village would have both a monument honoring the Union as well as the Confederacy, considering Maryland's role as a border state during the Civil War. Despite its status as a slaveholding

Residents once had the luxury of swimming at the Lakewood Swimming Pool, as seen here in 1943. The pool also had sand shipped in from Cape May, New Jersey, to form a beach. *EPFL*

state, Maryland rejected secession from the Union. Like many homes in Maryland, it is likely that there were homes with divided loyalty in the country estates of Charles Village at the time.

Four blocks north of the Union Soldiers and Sailors Monument is the Johns Hopkins monument on North Charles and Thirty-third Streets. The monument is the work of Baltimore sculptor Hans K. Schuler, who was also the director of the Maryland Institute College of Art from 1925 to 1951 and was known as the "Monument Maker." The Schuler School of Fine Arts continues today in Baltimore and is housed in Schuler's home, which is listed in the National Register of Historic Places.

Another recreational opportunity for Charles Village residents in the early 1930s was the Lakewood Pool, a semi-private swimming club that opened in 1932 at 2519 North Charles Street. Neighborhood residents enjoyed the cool respite from Baltimore's hot summers and the powder-white sand, as did Baltimore natives F. Scott and Zelda Fitzgerald and visiting entertainers appearing at the Hippodrome Theatre, including Milton Berle.

Oriole Park, seen here in the 1930s, was located in the 300 block of East Twenty-ninth Street, one of three homes to the Baltimore Orioles in Charles Village. *EPFL*

City Within a City

As discussed in Chapter Three, Charles Village was home to several Baltimore Oriole players in the late 1900s—and for good reason. The Orioles played in three stadiums in Charles Village: Oriole Park near Twenty-ninth Street and Greenmount Avenue in 1889, Union Park at the corner of Guilford Avenue and Twenty-fifth Street beginning in 1891 and the second Oriole Park (formerly named Terrapin Park) north of Twenty-ninth Street from 1914 until July 4, 1944, when the wooden stands burned. The original Oriole Park was only used for two years, as it was considered too far removed from downtown Baltimore. The second Oriole Park (formerly Terrapin Park) was instrumental in the everyday lives of children growing up in Charles Village. In 1937, a new scoreboard—reported to be thirty-five feet tall and as wide as four houses—was installed and was called the largest scoreboard in the world. Its electrical operation was revolutionary for the time, too. During the nighttime fire that broke out in 1944, 1,500 Charles Village residents were forced to flee their homes, and the heat melted asphalt on Twenty-ninth Street and tar on nearby roofs. Union Park was the site of what was called the "greatest game of the nineteenth century," when the Orioles played Boston on September 29, 1897. Over 30,000 fans attended, which was the largest crowd ever; however, Boston won, preventing the Orioles from winning their fourth consecutive National League pennant.

The neighborhood also contains the *Afro-American* newspaper at 2519 North Charles Street. Founded in 1892 by former slave John Murphy Sr., the *Afro-American* is the longest-running, African American, family-owned paper in the United States.

Throughout the years, Charles Village has been home to many artists, literary types and political activists, as evidenced by the Vietnam War protests in the 1960s and the Iraq War protests that took place in the neighborhood. Additionally, the Charles Village row house of William O'Connor, a professor of literature and sociology at the University of Maryland, Baltimore, was utilized as a planning headquarters for the infamous Catonsville Nine. The group, composed of Catholic peace activists, several of whom were priests, gained national attention when, on May 17, 1968, they entered the Selective Service building in Catonsville, Maryland, seized hundreds of draft records and burned them in the parking lot as an act of protest to the Vietnam War. In addition to helping to plan the act at his house, William O'Connor also helped make the homemade napalm, consisting of soap flakes and gasoline, which was used to burn the draft cards. The Catonsville Nine were arrested and sentenced to prison,

Vice President Richard Nixon commemorated the Orioles' Major League return to Baltimore on April 15, 1954, in a parade up Charles Street. The players were showcasing Oriole greats from past and present. *EPFL*

while some members went underground; some were captured by the FBI, while others eventually surrendered.

Residents also recall heavy involvement by neighbors in the 1970s with the Fair Housing and Back to the City initiatives. One of the neighborhood's most famous activists was Madalyn Murray (later Madalyn Murray O'Hair), who at one point was dubbed by *Life* magazine "the most hated woman in America" and once lived on North Calvert Street. A Pennsylvania native, Murray filed a lawsuit in 1960 against the Baltimore School District (*Murray v. Curlett*), in which she claimed that it was unconstitutional for her son William to participate in Bible readings at Baltimore public schools. Her case eventually reached the U.S. Supreme Court, and the lawsuit resulted in the removal of forced prayer and Bible reading from the public schools of the nation. She went on to file scores of church-state separation

lawsuits over the next thirty-two years and founded the American Atheists organization in Austin, Texas.

In 1995, Madalyn Murray O'Hair (she married Richard O'Hair in 1965) was kidnapped, along with two of her children, at gunpoint at the American Atheist headquarters in Austin. They were held in a San Antonio hotel for a month, while $600,000 in gold coins was obtained from an American Atheist account in New Zealand for the ransom. After the ransom was collected, the family believed they would be released; however, the family vanished. It took a year for Bill, an estranged Christian son, to finally file a missing person's request. It took three more years for the FBI to become involved; its involvement was due to the diligent investigative work of a *San Antonio Express-News* reporter. The O'Hairs had been missing more than five years by the time their charred, sawed-up bodies were finally unearthed from a shallow grave on a ranch in south Texas. Along

A regular weekend fixture along the 100 block of East Twenty-sixth Street in the 1960s, the Twenty-sixth Street Art Mart fostered community involvement and allowed local artists to sell their wares. *EPFL*

The National Guard descended on Twenty-fifth Street in Charles Village for precautionary reasons during the turbulent 1960s after the Reverend Martin Luther King Jr.'s tragic assassination. *EPFL*

with them in the grave was a black garbage bag containing a fourth head and a pair of hands.

The neighborhood's political activism is evident today in activities like those in November 2008, when an impromptu street party broke out on St. Paul Street as residents and college students took to the streets to celebrate Barack Obama's presidential victory.

City Within a City

Today, the neighborhood is home to professors, students, professionals, artists and residents who span every demographic category. Residents are dedicated to Charles Village, and in 2008, Charles Village was recognized by the American Planning Association as one of the "10 Great Neighborhoods in America." The committee cited "the neighborhood's strong and dedicated activist community, economic and social diversity, and memorable character enhanced by designs from the renowned Olmsted Brothers firm" as some of the reasons for the designation. The APA also noted:

> *Ethnically and socially diverse, Charles Village is home to everyone from college students and blue-collar workers to young families and older singles. Residents have been called "typically atypical," which makes for the unusual at times: a rusted typewriter in a local artist's front lawn or an activist gardening group that keeps tabs on unattended garden plots and tree wells. "It's not stodgy," says local resident Nancy Charlow. "That's the thing I like about the neighborhood. It doesn't take itself too seriously."*

BIBLIOGRAPHY

Arthur, Catherine Rogers, and Cindy Kelly. *Homewoood House*. Baltimore, MD: Johns Hopkins University Press, 2004.

Atlas of the City of Baltimore, Maryland (1906): George W. and Walter S. Brawley.

Baltimore City Archives. Tax Assessments, Vertical Files, Special Collections.

Baltimore Land Records, Deed Office. Real Estate Deeds.

Baltimore Legislative Library, City Hall. Tax Assessments, Photographs, Maps.

Baltimore, Maryland: The Monumental City, A Souvenir of the One Hundred and Twenty First Anniversary of the Baltimore American, 1773–1894. Baltimore, MD: American's Job Printing Office, 1894.

Brown, Bob, ed. *The House of Magic 1922–1991* (Memorial Stadium). Privately printed, 1991.

Clark, Charles. *The History of Landmark Lodge*. Baltimore, MD: R. Beaveridge & Son, 1911.

Distinguished Men of Baltimore and of Maryland. Baltimore, MD: Baltimore American, 1914.

Enoch Pratt Library, the Maryland Room. Vertical Files, Special Collections.

Fein, Isaac M. *The Making of an American Community: The History of Baltimore Jewry from 1773 to 1920*. Philadelphia: Jewish Publication Society of America, 1971.

Genealogy and Biography of Leading Families of the City of Baltimore and Baltimore County, Maryland. New York: Chapman Publishing Company, 1897. Reprinted by Higginson Book Company.

Hall, Clayton C., ed. *Baltimore: Its History and Its People*. 3 vols. New York: Lewis Historical Publishing Co., 1912.

Kelly, Jacques. *Peabody Heights to Charles Village*. Booklet, 1976.

————. *The Pratt Library Album; Baltimore Neighborhoods in Focus*. Baltimore, MD: Pratt Free Library, 1986.

Lewand, Karen. *North Baltimore from Estate to Development*. Baltimore, MD: University of Baltimore, 1989.

Maryland Historical Society. Baltimore City Directories, Vertical Files, Special Collections.

Musser, Frederic O. *The History of Goucher College, 1930–1985*. Baltimore, MD: Johns Hopkins Press, 1990.

Our First Fifty Years, 1898–1948. (Maryland Casualty Company). Privately printed, Maryland Casualty Co., 1948.

Peale Museum. Photographic Files, Vertical Files, Special Collections.

Schmidt, John C. *Johns Hopkins: Portrait of a University*. Baltimore, MD: Johns Hopkins Press, 1986.

About the Authors

Gregory J. Alexander is a Baltimore-based freelance writer for the *Baltimore Sun*, *Howard Magazine* and the *Annapolis Capital* and editor of *Mason-Dixon ARRIVE*, a monthly lifestyle magazine, as well as owner of Pen & Ink, LLC. Alexander earned a bachelor's degree in journalism from the University of Georgia.

Paul K. Williams is proprietor of Kelsey & Associates, a historic preservation firm, and director of Historic Dupont Circle Main Streets in Washington, D.C. Williams earned a bachelor's degree in historic preservation from Roger Williams University and performed graduate work at Cornell University. The authors own a one-hundred-year-old Victorian home in Charles Village, along with a nineteen-year-old cat, Minnie, and a rescued retired greyhound, Herschel.

Visit us at
www.historypress.net